BRAMHALL

THROUGH TIME

Simon Crossley &
Paul Chrystal

AMBERLEY

For Rachael

Other books by Paul Chrystal:

The Rowntree Family: A Social History
Cadbury & Fry Through Time
Tea: A Very British Beverage
Coffee: A Drink for the Devil
Chocolate: The British Chocolate Industry
In Bed with the Ancient Greeks
Women in Ancient Rome
York Past & Present

First published 2016

Amberley Publishing
The Hill, Stroud, Gloucestershire, GL5 4EP
www.amberley-books.com

Copyright © Simon Crossley & Paul Chrystal, 2016

The right of Simon Crossley & Paul Chrystal to be
identified as the Authors of this work has been asserted
in accordance with the Copyrights, Designs and
Patents Act 1988.

ISBN 978 1 4456 6226 8 (print)
ISBN 978 1 4456 6227 5 (ebook)

British Library Cataloguing in Publication Data.
A catalogue record for this book is available from the
British Library.

Origination by Amberley Publishing.
Printed in Great Britain.

Introduction

Bramhall is a thriving, bustling and leafy suburb of Stockport, close to Manchester. It has been voted the least 'lonely place' in Britain – according to research from the University of Sheffield, Bramhall came bottom of the loneliness index nationwide. It also boasts a rich history stretching back to Anglo-Saxon times.

Bramhall Through Time takes us back to Bramhall's early history to meet the Saxon lords Brun and Hacun, whose lands were given by Willliam the Conqueror to Hamon de Massey, who eventually became the first Baron of Dunham Massey. The Edwardian shops and businesses in the village centre have been replaced by trendy boutiques and cool bars clustered around the historic village square. We visit the elegant (yet confusingly spelt) Bramall Hall with its beautiful park, and we go to farms and shops in the area.

The book also takes in neighbouring Cheadle and Cheadle Hulme, Gatley, Hazel Grove, and Ringway-Manchester International Airport where, again, old and new pictures are juxtaposed to show how things have changed in these communities over the last 100 years or so.

Cheadle and Cheadle Hulme

As with Bramhall, Cheadle gets its first mention in the Domesday Book, where it is recorded as '*Cedde*', Celtic for 'wood'. Silk weaving was a vital industry here; work took place in domestic cottages in a room known as a loomshop and much of the woven silk was sold to firms in Macclesfield. Blues veteran John Mayall and Dame Felicity Peake, founder of the Women's Royal Air Force, were both born here.

Gatley

In the seventeenth and eighteenth centuries Gatley was noted for its button making, but was largely dependent on textile manufacturing with many residents working as handloom weavers living in cottages with cellars for storage and well-lit upper rooms for the looms.

Hazel Grove

Hazel Grove was known, somewhat inelegantly, as Bullock Smithy until 1836 when, because it didn't sound very posh, it was renamed, possibly after the hazel trees found in the area, or after a corruption of the name of a hamlet near High Lane called Hessel Grave. The SK7 postcode, which also takes in Bramhall, is reputedly one of the most sought-after residential postcodes in Greater Manchester. Hazel Grove comprises three separate townships: Norbury, Torkington and Bosden-cum-Handforth; Norbury ('Nordberie') is mentioned in the Domesday Book. Significantly, in 1560 Richard Bullock built a smithy on the corner of Torkington Park, which later became the Bullock Smithy Inn and gave its name to the area. Adidas' main warehouse is on the outskirts of Hazel Grove.

Ringway/Manchester International Airport

Aviation took off at Ringway, as Manchester International Airport was called, in 1938. During the Second World War, it was known as RAF Ringway and specialised in military aircraft manufacturing and training parachutists. The first scheduled flight was a KLM operated Douglas DC-2 to Amsterdam; KLM was the only international operator flying out of Ringway and offered a request stop at Doncaster. Manchester's first municipal airfield was Manchester Wythenshawe Aerodrome from 1929, and then Barton Aerodrome (1930) just west of Eccles, which was intended to be the principal airport for Manchester, but its small marshy grass airfield was totally inadequate for the larger airliners entering service, such as the Douglas DC-2 and DC-3.

Acknowledgements

The authors would like to thank Mark and Trish Wright at MA Archive via Ringway Publications for the photos of Manchester Airport; Eric Jackson (www.statementartworks.com) for permission to use the fine example of northern poster art on page 34; Andrew at Simply Books, award-winning booksellers in Bramhall; Poynton Players Amateur Dramatic Society; Neil Roland at 'Signs of the Times'; Annie Glover; David Cavell for the photos on pages 23 and 26; Neil Corry at Corry's, prizewinning butchers in Bramhall; the Juniper café in Bramhall; Brian Barnes and Chorlton Runners for the action shot on page 38; James Milligan for allowing me access to his superb collection of Bramhall and Cheadle postcards; and finally, Coral Dranfield and her colleagues at Stockport Heritage Trust for generously providing information and advice and for allowing me to plunder their wonderful archive housed as it is in its wonderful setting (http://stockportheritagetrust.co.uk). Finally, the area in and around Bramhall is blessed with a plethora of fine pubs: my thanks must go the landlords and staff of these, many of which are included in the book, for their hospitality and generosity. Such are the rigours of historical research.

Local people have been extraordinarily generous and accommodating during our research for this book and in the provision of photographs and old postcards, and so it is them whom we must thank for making this book what it has eventually become. It is worth repeating that without the help of these local people, *Bramhall Through Time* would be a significantly diminished production.

Unless otherwise stated, all the modern photography is by and © Paul Chrystal.

Simon Crossley, Chorlton (www.sidigitaldesign.com)
Paul Chrystal, York (www.paulchrystal.com)

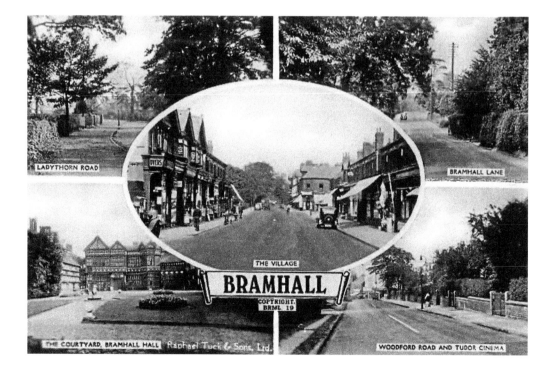

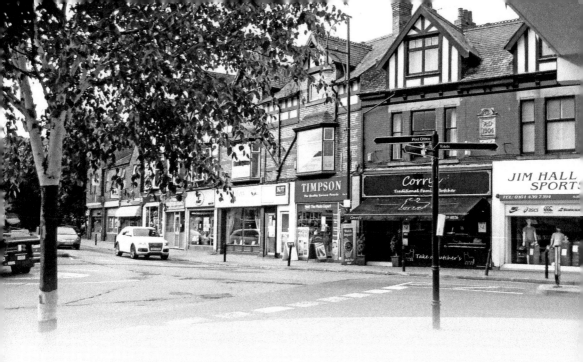

CHAPTER 1

Bramhall

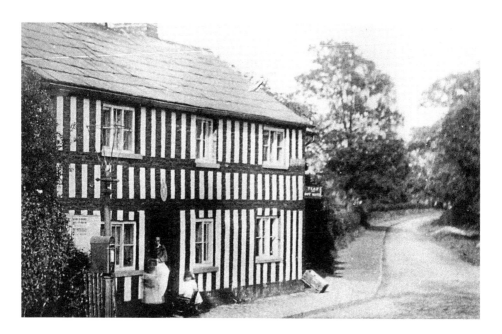

Bridge Lane, 1901

Tudor beams and a gaslight characterise this turn-of-the-century scene with teas and hot water available at what was an early café. This view is looking down Bridge Lane from Bramhall Green, formerly called Mill Lane after nearby Bramhall Mill in the Ladybrook Valley. The mill was owned by William Davenport who, after a spat with the miller, Mr Hampson, petulantly removed the roof and allowed it to fall into disrepair. The modern picture is the Green today. The lower image on page 5 shows one of the impressive signs welcoming visitors to the village.

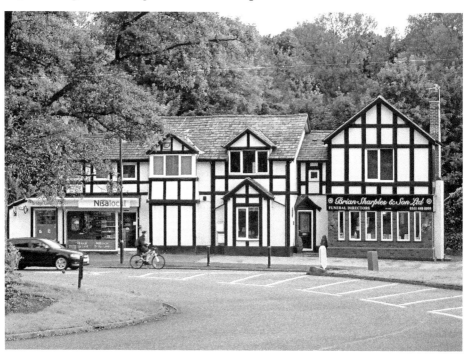

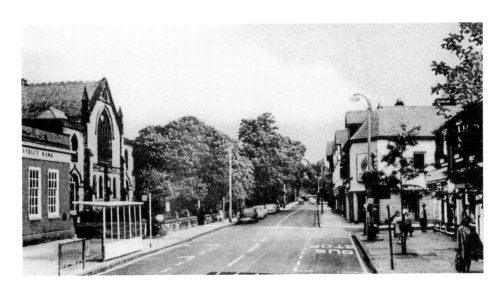

Bramham Lane South and a Taste of Thailand

A typical early scene devoid of motorised traffic, with the Methodist chapel on the left. Our earliest reference to Bramhall was recorded in the Domesday Book (1086) as 'Bramale', a name formed by the compounding of the Old English words *brom* meaning 'broom', and and *halh* meaning a 'secret place', probably near water – both broom and nooks could be said to be native to the area. The new photo shows a very different, more exotic Bramhall Lane today.

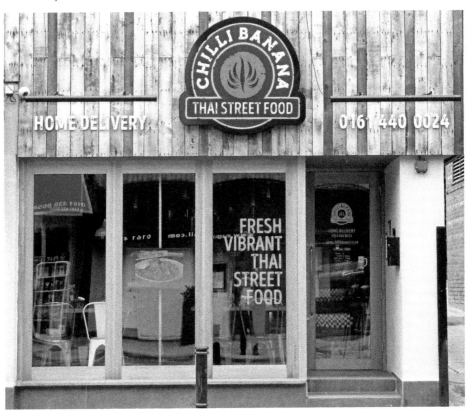

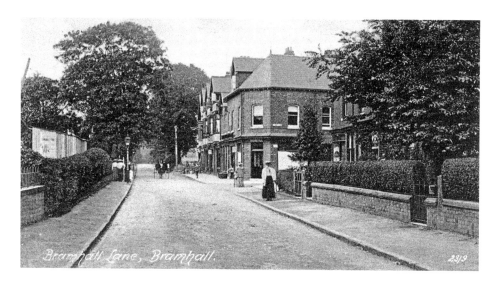

Bramhall Lane South and Lumb Lane

This is the junction of Lumb Lane. The shops on the right were built by William Adkinson in the 1890s with temporary wooden huts for Adkinson's men during the construction of the Methodist chapel. Methodism started in Bramhall in 1860 when four Methodists from Cheadle Hulme met in Thomas Hough's cottage in Pownall Green. A plain brick building accommodating 180 worshippers was built in Bramhall Lane in 1871, and was replaced in 1910 with the building we see today. The old chapel then became the Sunday school. More exotic dining options are shown in today's photograph.

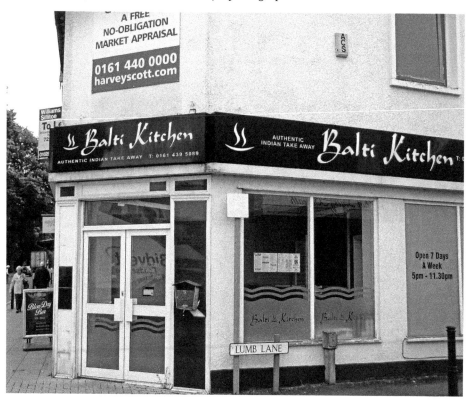

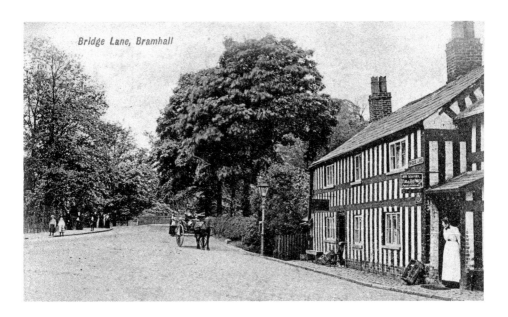

Bridge Lane, Bramhall

Bramhall Green

Bridge Lane is seen here at Bramhall Green in 1905, with Mrs Simpson's café on the right catering for visitors to Bramall Park. The Green was home to the Shoulder of Mutton pub, a blacksmith and a tailor. Womanscroft Bridge over the Ladybrook can be seen behind the trap. Bramhall Green was the original epicentre of the village, opposite Bramall Park gates. The village pinfold was here too: a pinfold was an animal pound where stray livestock were kept until claimed by their owners and released on payment of a fine. Also here were the stocks, a police house, a school, a water mill (which led to the lane being renamed Mill Lane before it was Bridge Lane) and Clarke's Farm. It was the railway that caused the village to be moved to its present location down the road, as it was built closer to today's village centre.

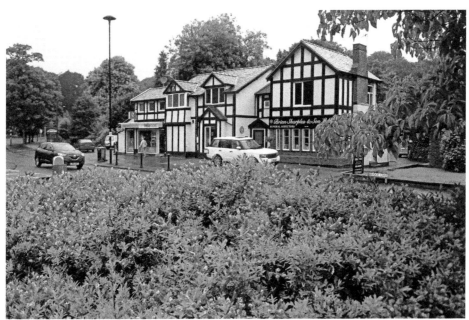

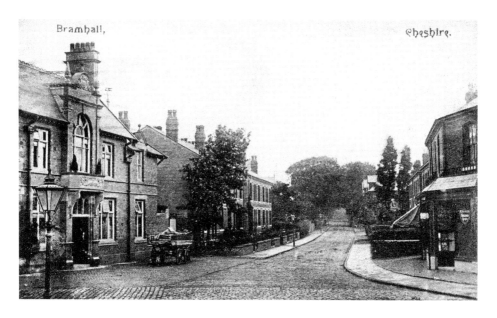

The Victoria Hotel

Taken some time after 1905, this card shows the village centre looking down Bramhall Lane towards Stockport. The hotel is the prominent building on the left on the corner of Ack Lane, in front of which is one of the gaslights first erected in 1899 by Stockport Corporation. Things started to change with local facilities in 1929 when the Urban District Council provided electricity for many Bramhall and Hazel Grove residents. The current Victoria boasts two interesting ceilings showing vintage maps of the world and are best viewed while lying on the floor.

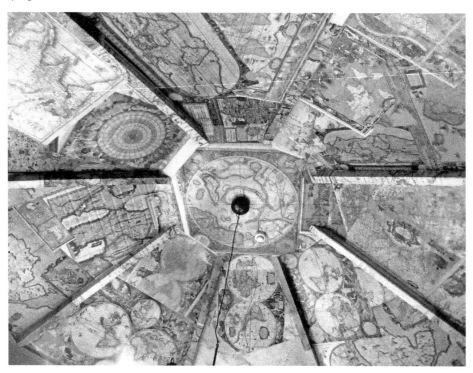

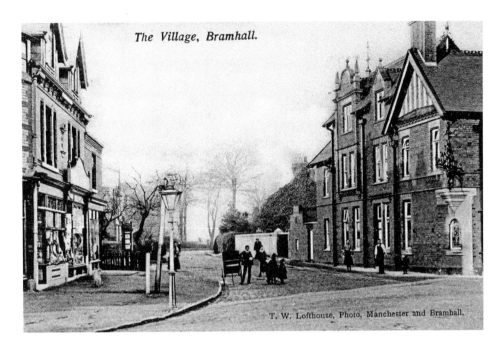

The Village, Bramhall.

T. W. Lofthouse, Photo, Manchester and Bramhall.

Ack Lane

The Victoria hotel is on the right as we look down Ack Lane towards Cheadle Hulme. It marks the end point of the commercial development in the village until 1929. The modern precinct is beyond there today. Ack Lane has also been known as Hack Lane in the past. The exterior of the current Victoria is in the new picture – beer supplied by J. W. Lees, independent family brewers of Middleton, Manchester, since 1828.

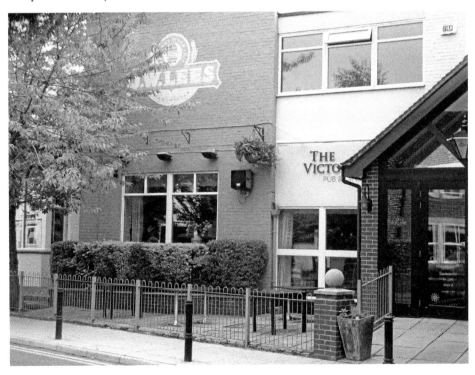

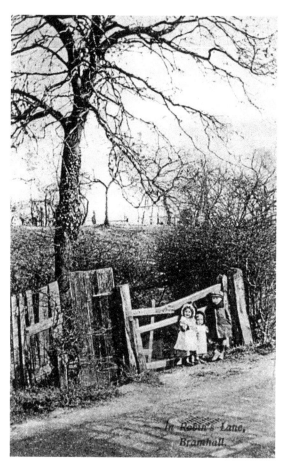

In Robin's Lane, Bramhall.

Robins Lane and Station Lane
Wrapped up on a cold looking day in Robin's Lane off Bramhall Lane South. Nearby is a track leading into Carr Wood and the crater left by an exploding landmine from the Second World War. Similar interest in what is called Station Lane on the lower card.

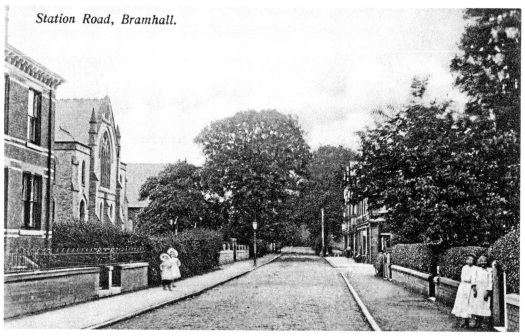

Station Road, Bramhall.

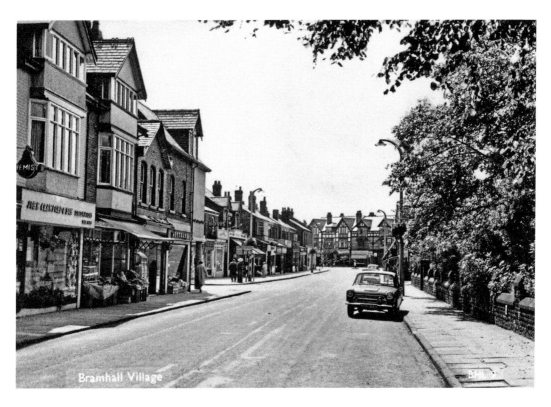

Bramhall Village

Bramhall Centre

A typical shot of the village from Bramhall Lane south looking towards Ack Lane, with some bad parking on the right.

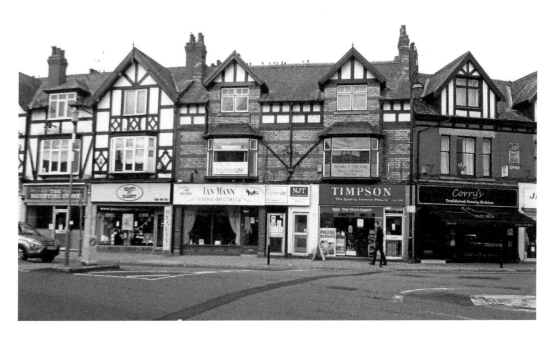

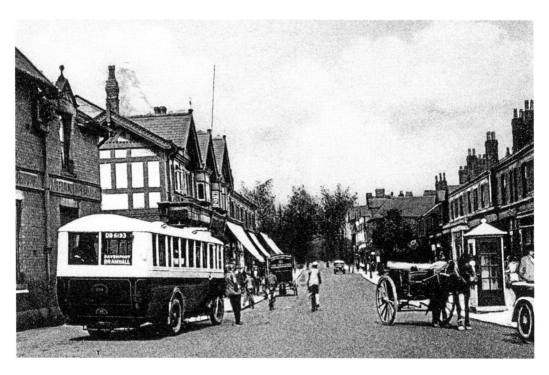

Bramhall Lane 1920s

Things were starting to change in the 1920s with motor buses and cars coexisting with bicycles and horses and traps. There is an early phone box on the right. Mercato's typifies the businesses trading here now, adding to the comfortable, comparatively affluent ambience of the place. Mercato's is in the building once occupied by Corrie's the butchers.

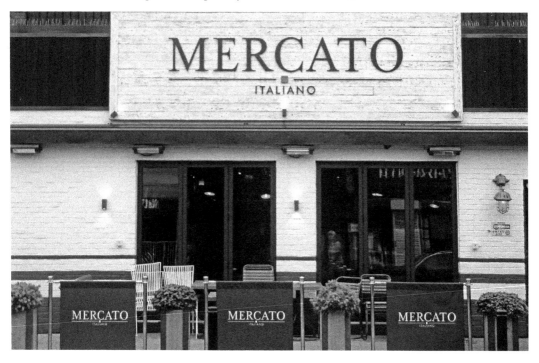

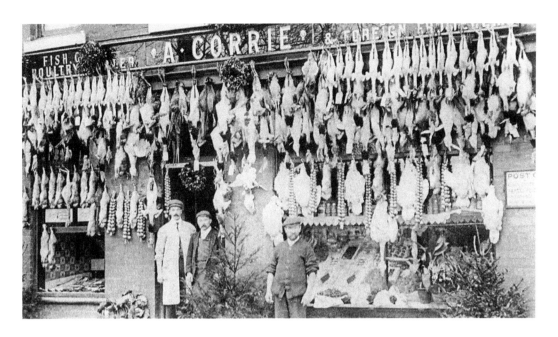

Corrie's and Corry's

Orginally a greengrocer's built by W. L. Atkinson, this shows Corrie's in all its glory with a fine display of poultry around Christmas 1938; the sign advertises local and foreign fruits. By this time the shop had extended into two neighbouring houses. The post office on the right was run by Peter Rhodes from his front room; he had been coachman for Cyrus Slater of Ack Lane but, sadly, he developed Parkinson's disease and was helped by Slack to open the post office. Services included insurance, annuities, money orders and telegraphs. When he deteriorated, his sister Miriam took over the business when she was just seventeen. A different Corry's now trades in Ack Lane East: award-winning Corry's butchers are members of the prestigious and select Q Guild of butchers of which there are only 120 in the country.

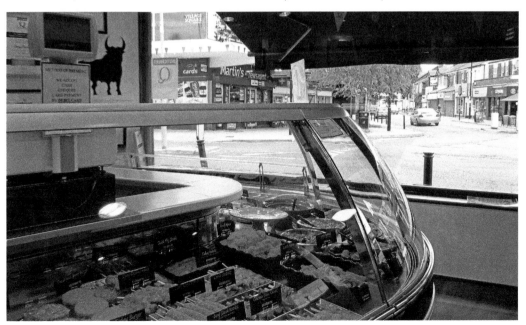

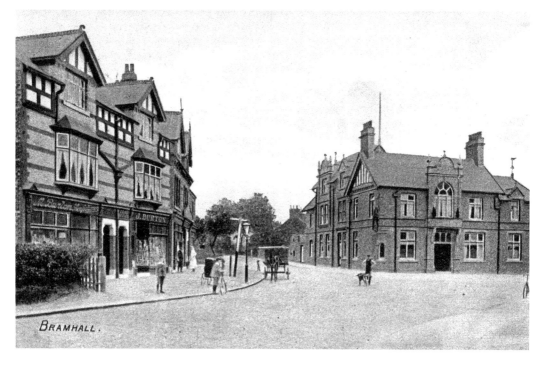

Victoria and 'Bramhall Red'

The second of three 'Victoria' pubs in Bramhall, this one was built in 1905 on the site of the first one on the corner of Ack Lane and Bramhall Lane. It opened with landlord James Hough and was demolished in 1967. In the early twentieth century, it was the only pub in the centre of the village. The new image is another of Neil Roland's artworks, *Bramhall Red*, which imaginatively captures the reddish qualities of the village by way of postboxes, a local barber's shop, art deco residential windows in Bramhall Lane, and stained glass from St Mary's and the Methodist church. This and other art works can be seen in the Juniper Café and in Neil Roland's Didsbury studio.

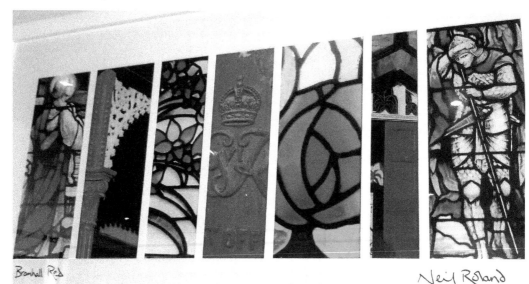

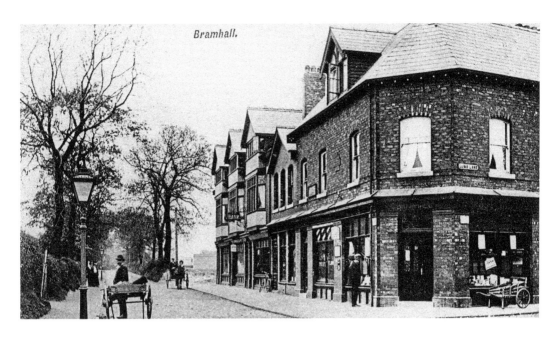

Bramhall.

Bramhall Post Office

By 1889, postal business was on the up, so Peter Rhodes moved his activities (along with the stationery side of the business he had added) to the corner of Lumb Lane. Ingeniously, when letters were posted in the letter box here they fell straight down a chute in to the sorting office, which was in the cellar beneath the shop. This shop was superceded by the Maple Road post office in 1953 and the retirement of Cephas Rhodes, brother of Miriam Rhodes, in 1962, aged seventy-five. In the lower picture, we see Henry Glover's wheelwright business (started 1870) and grocery shop crowding in on the stationery shop there which later became the post office. Glover later opened a lawnmower repair business where his wheelwright business was.

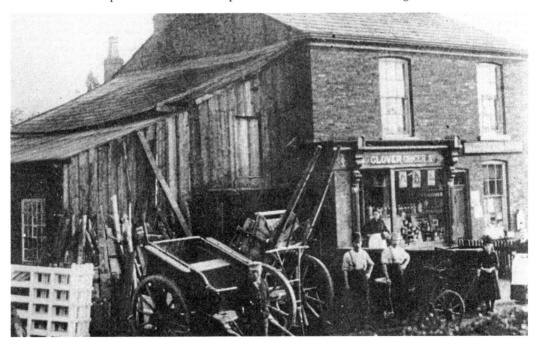

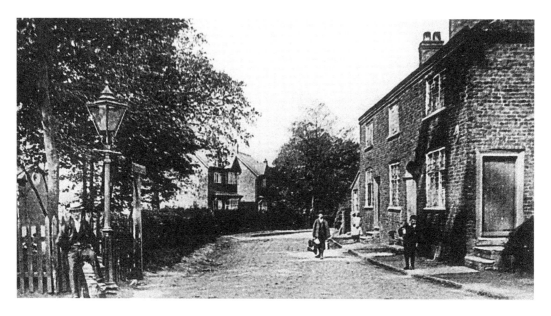

Robins Lane Silk Weavers

Some of the cottages inhabited by the silk weavers at the corner of Robin's Lane and Pownall Green. The one on the far right is an outshut loom shop. We know about the twenty-one weavers living around here from the 1841 census. Some of the cottages were damaged by a landmine in the Second World War; they were demolished in the 1950s for road widening. In 1871, the Methodist chapel opened here and Bramhall's first board school was established at Pownall Green. Pownall Hall was here; passed from the Pownall family through the female line to the Brocklehurst family of Macclesfield in 1858 and was occupied until 1968 when it was demolished. The front room was used as the local food office during the Second World War. It is now a pleasant care home where the reception area is decorated with some interesting vintage photos of Bramhall. The modern photo shows the junction today with the United Reform Church on the corner.

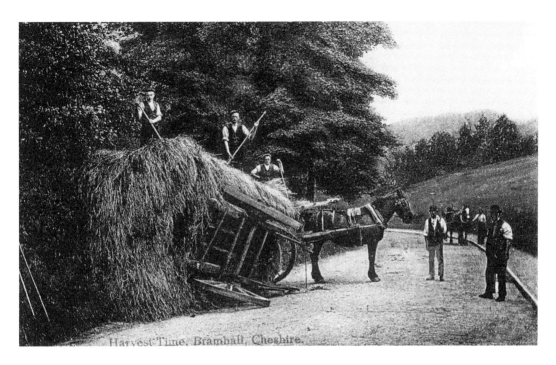

Harvest-Time, Bramhall, Cheshire.

Harvest Accident

This hay cart overturned on Bramhall Lane, en route for Clarke's Farm. The farm was demolished in 1920. In 1858, Sarah Pownall married John Brocklehurst, whose son William restored the cottages in 1895; his initials are inscribed there. John set up a silk throwing firm, which became England's largest silk cloth manufacturers under his other sons, John and Thomas. The lower image shows haymaking at Grange Farm – one of Bramhall's largest when it took over land from Yew Tree farm. The owner, aptly named John Fallows, is shown here on the right in 1890 looking very much in charge.

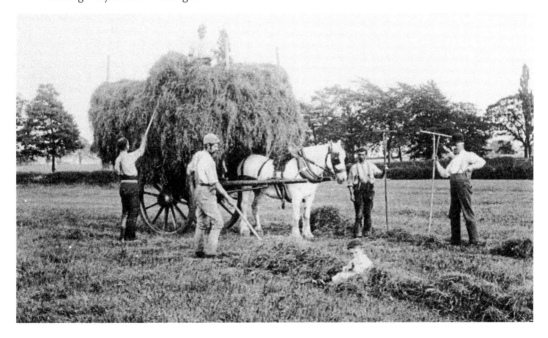

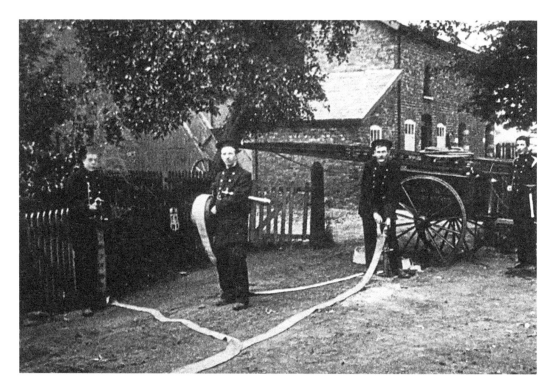

Bramhall Firemen and Reverend Macdona

Bramhall's firemen are pictured here around 1900 with their horse-drawn engine and hose, which were kept in a shed on Lumb Lane. Horse power was provided by Mr Pridgeon at the blacksmith's. The firemen were all volunteers. The lower image is of Reverend Macdona, the rector of St Mary's Church, shown here in 1905 inspecting a detachment of the 3rd Battalion Cheshire Regiment.

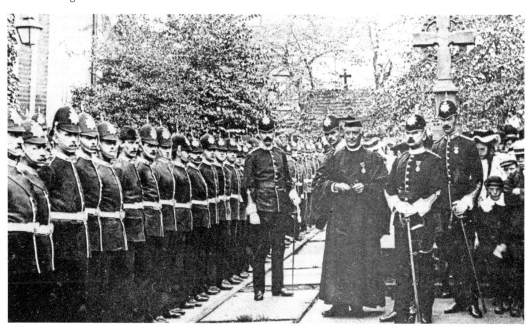

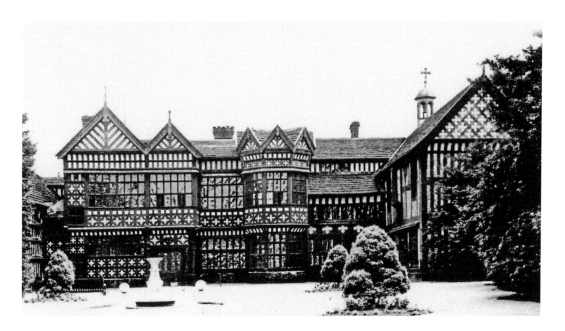

Bramall Hall

The artificial lakes were developed by Charles Nevill when he diverted the Ladybrook and provided himself with a ready supply of trout for his fishing. The hall is a Tudor timber-framed building, dating from the fourteenth century with additional elements from the sixteenth and nineteenth centuries. Why the confusing spelling? The Domesday Book used 'Bramale', which led Charles Nevill to call it 'Bramall', the name taken on by Hazel Grove and Bramhall Urban District Council when it acquired the property and adopted later by Stockport Council. The new image is of the hall receiving the finishing touches to its restoration and grand reopening at the end of July 2016.

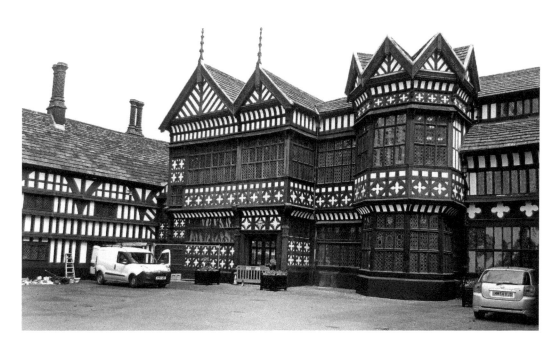

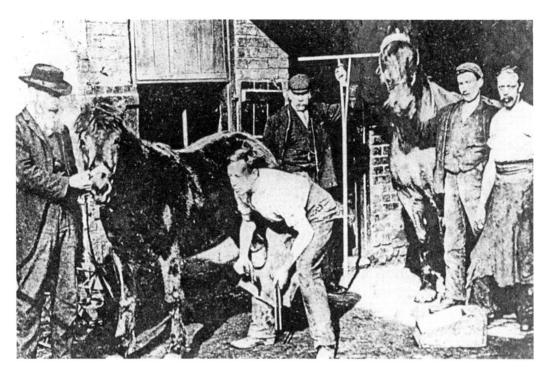

Ford's Lane Smithy, 1900

The smithy was opened by James Ford in the 1870s. In the upper photograph, John Ford is the smithy and farrier hard at work on the horse at the front here while Joe Ford is on the far right with the horse, named Britain, and the owner Elias Holland.

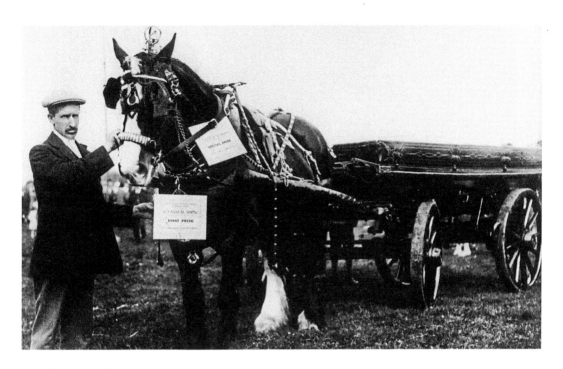

Bramhall Show, 1927

The Bramhall Show owes its origins to a meeting of nine men in the billiard room at Mr T. A. Addeyman's house, Hillbrook Grange. The inaugural show was held the following summer in a tent in a field off Ack Lane, but it then took place in the grounds of Bramall Hall for the next thirty years. Rules were strict. The three allowable category sections were: gentlemen gardeners, cottagers living within 3 miles of Bramhall station; and farm and dairy produce from within a 5-mile radius. Agricultural entries were only allowed later. The society is now known as the Bramhall, Cheadle Hulme & Woodford Agricultural & Horticultural Society. The picture shows a lucky first prizewinner and a special prizewinner in 1927.

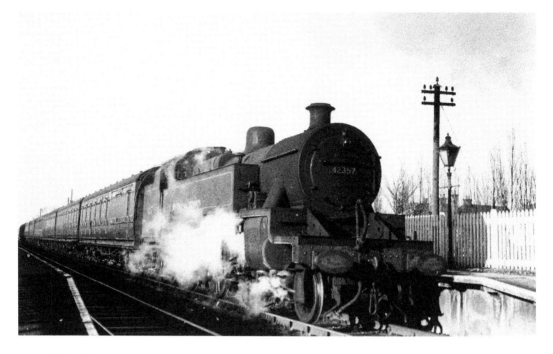

Bramhall Railway Station

The station is 10 miles south of Manchester Piccadilly on the Stafford to Manchester Line. It was opened in 1845 by the London & North Western Railway. Today, southbound services to Birmingham New Street and London Euston, and northbound services to Manchester Piccadilly, hurtle through the station. It was the siting of the station that led to the shift of the village away from the Green to its present location.

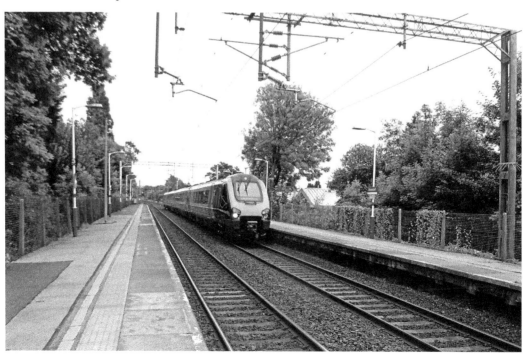

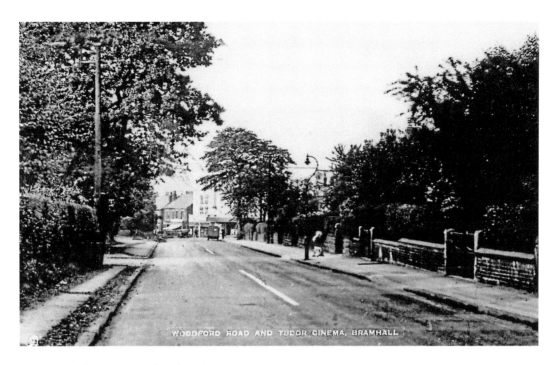

Woodford Road and Tudor Cinema

The cinema, bottom right, was demolished in the early 1960s despite appeals for its preservation. In her *Linked: Stories from One of a Family's Parts*, Anne Carr remembers the portrait of Henry VIII 'glaring down' at them from the screen, flanked by his six wives. Cowboy films such as *Lassie* and *Just William* were staple fare, although one visit to a Charlie Chaplin movie went wrong when, instead of the expected *Little Tramp* comedy, *Monsieur Verdoux* was screened – a film in which Chaplin murders his wife – and would forever scare the wits out of Anne whenever she saw a man remotely resembling Chaplin.

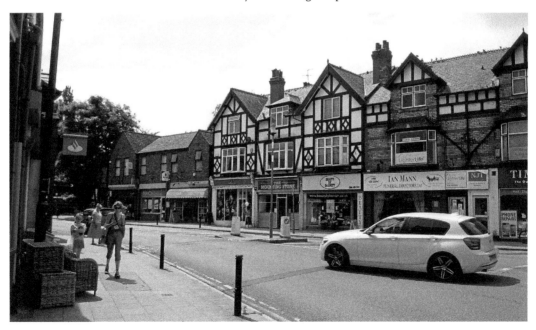

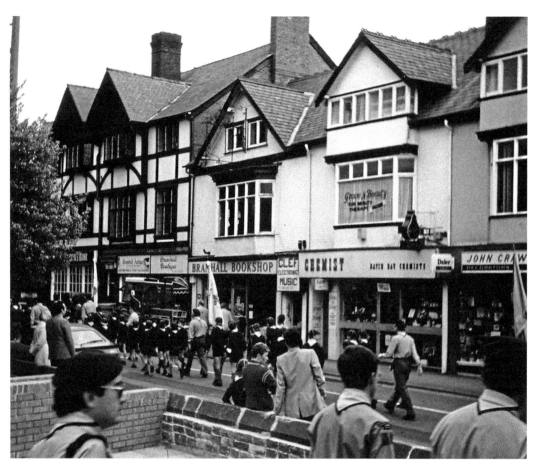

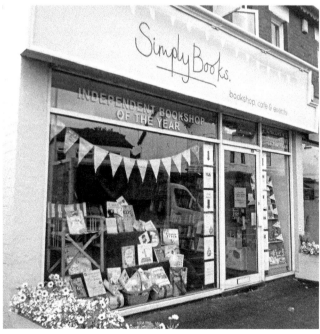

Bramhall Bookshops
The top picture shows the Bramhall Bookshop at Nos 44–45 Bramhall Lane during the celebrations of the seventy-fifth anniversary of the 1st Bramhall Scout Group in 1984. The current bookshop, however, is the award-winning Simply Books at No. 228 Moss Lane, where the stocking and selling of books is complemented by a café, the Simply Cinema, book clubs and regular events, which have recently included celebrations of the 200th anniversary of Charlotte Brontë's birth, and a talk and book signing by *Great British Bake Off* winner Nadiya Hussain.

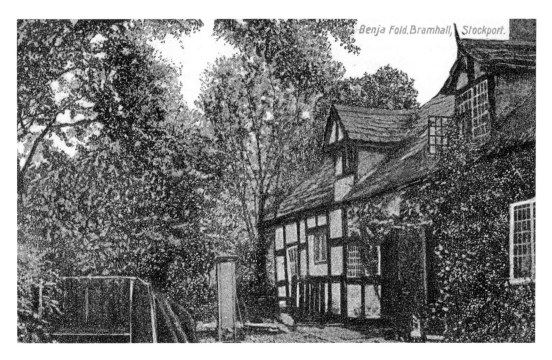

Benja Fold

Home to cruck-framed cottages; the thatched one was where handloom silk weavers lived – Ann Leah and Edward Bennett. A loom shop was joined to the gable end of the cottage.

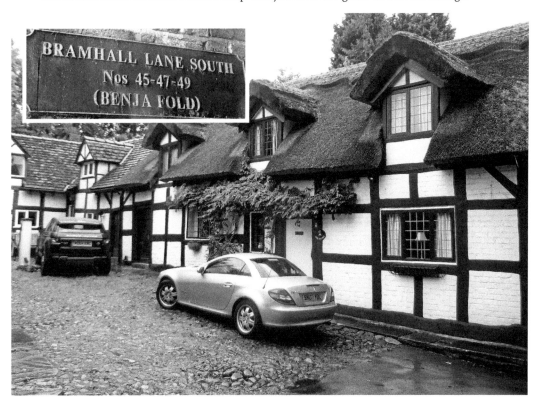

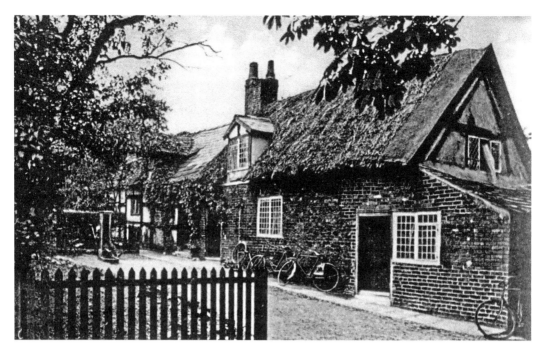

Benja Fold

The fold gets its name from Benjamin Birchenough. It was later owned by Peter Pownall, a Unitarian who refused the Methodists' permission to use his barn as a chapel. Villagers trudged long distances to and from that water pump.

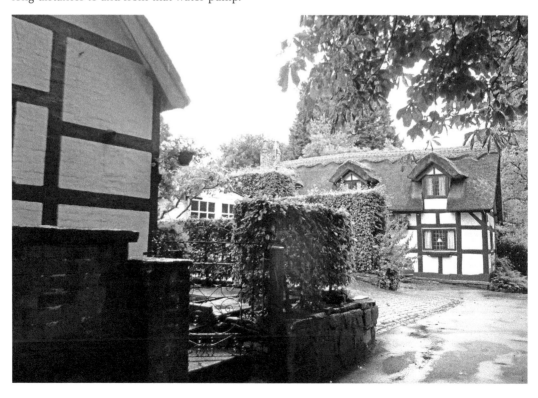

The Jolly Sailor

The original pub – dated 1778 – was part of a complex comprising the pub and three cottages. Belying its name somewhat, it was the occasional venue for Stockport Poor Law Union at which the annual overseers were elected. In around 1890, this area was known as Charlestown. The present Jolly Sailor, pictured here, opened in 1895, and received the licence previously held by the Leg of Mutton. The pub is said to be named after Admiral Salusbury Pryce Humphries of Bramall Hall – scapegoat for the 1807 Chesapeake incident.

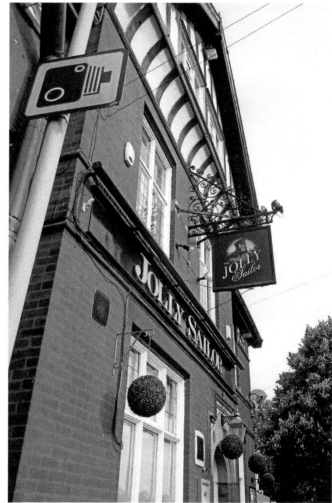

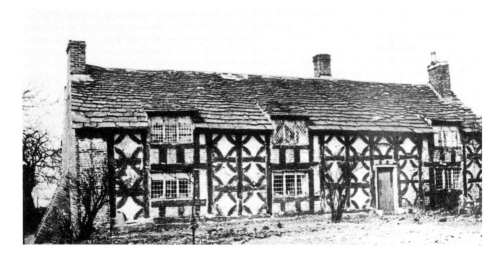

Yew Tree Farm and Davenport
An unending story of disappointing neglect and closures, the original farm building was half-timbered but injudiciously replaced in parts by brick. It became dilapidated by 1888 and was eventually pulled down to make way for the Bramhall Lane bridge over the Midland Railway that took the line into Manchester Central from 1902. The line closed in 1962. The lower image is of Davenport railway station which is 7 miles south-east of Manchester Piccadilly on the line to Buxton. It was opened by the Stockport, Disley and Whaley Bridge Railway in 1858, following a complaint by landowner Colonel William Davenport that the company had not honoured its pledge to provide a station at Bramhall Lane; it closed in September 1859 due to lack of traffic but reopened on 1 January 1862.

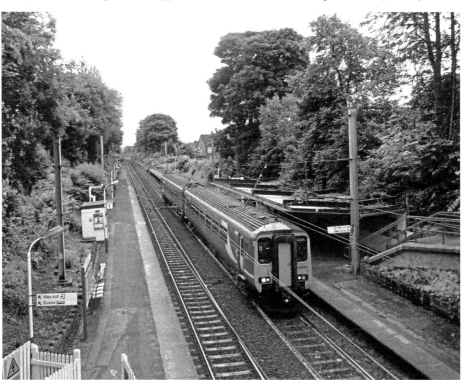

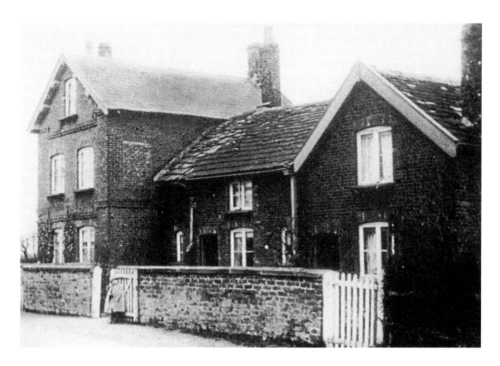

Police Cottage

One of three cottages around Pownall Green, which according to the 1871 census were originally occupied by silk weavers. The police residence moved from Bramhall Green to the cottage on the right in the early part of the twentieth century. The building on the left has since been demolished. Fords Lane in 1910 is the subject of the lower image.

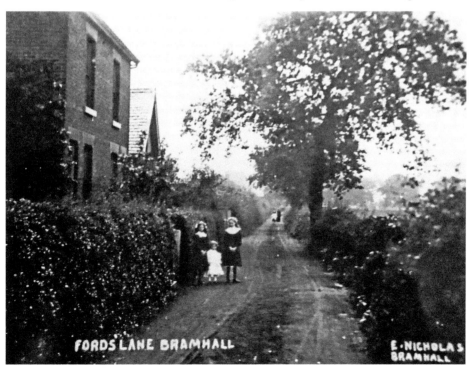

FORDS LANE BRAMHALL

E. NICHOLAS
BRAMHALL

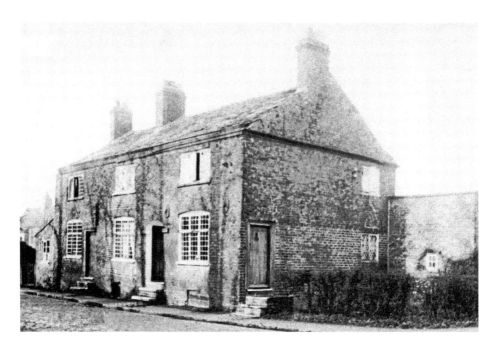

Robins Lane Cottages

Only one of these cottages remains today after bomb damage and road widening claimed the others. They were originally silk weavers' cottages – the loom house can be seen on the right. Workloads were collected from Macclesfield and finished items, 'pieces', returned there for payment. Paltry payment and unreliable work opportunities led to the industry getting the name 'poverty-knocking'. In 1885, Alfred Burton lamented the demise of this skilled trade when he wrote: 'the rickety-rack of the loom accompanied by the song of the weaver, and the sight of a cheery county face and white apron at the door is now rapidly becoming a memory of the past'.

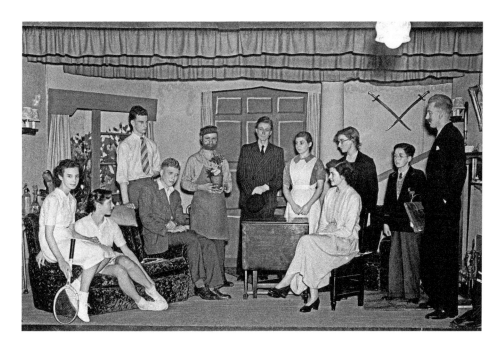

Poynton Players Amateur Dramatic Society

Two productions by the prolific Poynton Players from nearby Poynton. The older one is from 1955 and is a junior players' production of *The Rising Generation*; the newer is a scene from *'Allo 'Allo* by Jeremy Lloyd and David Croft from November 2015. Who is that German officer second from the left? The website tells us that Poynton Players was established in 1931 as Poynton Dramatic Society and has remained active in and around the village ever since. From the late 1930s up to the end of 1949, all productions were presented at the art deco 920-seat Brookfield Cinema on London Road. The Poynton Players are now at the Poynton Theatre, George's Road West (www.poyntonplayers.co.uk/archive.html).

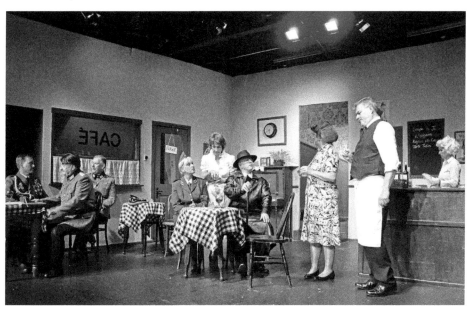

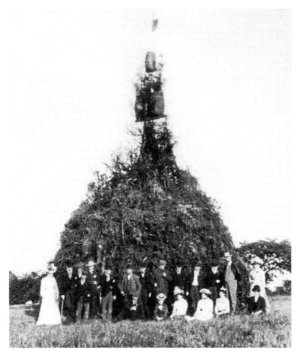

Diamond Jubilee Bonfire
One of the more inventive ways of celebrating Queen Victoria's Diamond Jubilee in 1897. Hymns and *Rule Britannia* were sung as the villagers processed, while a telegram composed by the children of Bramhall was sent to the queen. The site was between Ack Lane and Robins Lane where Convamore and Glenholme Roads are today. The modern poster is by Eric Jackson, whose satirical northern poster art can be seen at www.statementartworks.com. This particular one was designed soon after the UK's decision to leave the EU in June 2016, and although it is open to a number of interpretations, consolation comes from the fact that Bramhall is more than well-equipped to help you drown your sorrows.

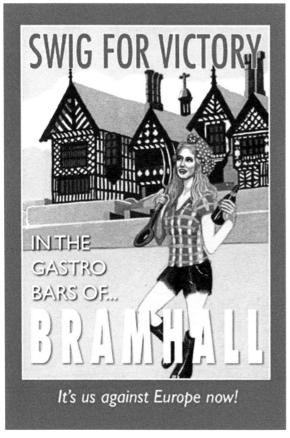

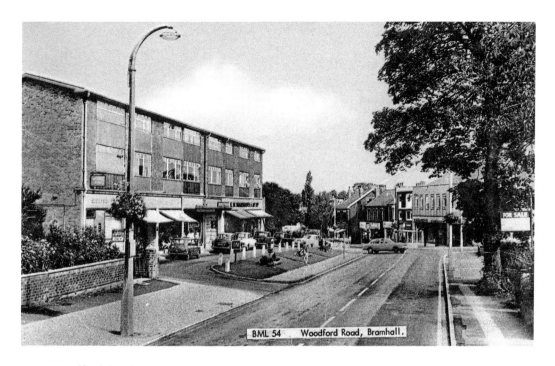

Woodford Road

Nothing much has changed here between the time when the two shots were taken – 1976 and 2016. The Midland Bank is, of course, now the HSBC. Woodford Aerodrome opened in 1924 and is where Avro, part of the Hawker Siddeley Group from the mid-1930s, produced aircraft such as the Avro Lancaster, turning out over 4,000 in the Second World War. Woodford closed in 2011 and was demolished in 2015. Shackleton maritime reconnaissance aircraft Vulcan bombers were also built here. George Best and Cristiano Ronaldo both lived in Woodford.

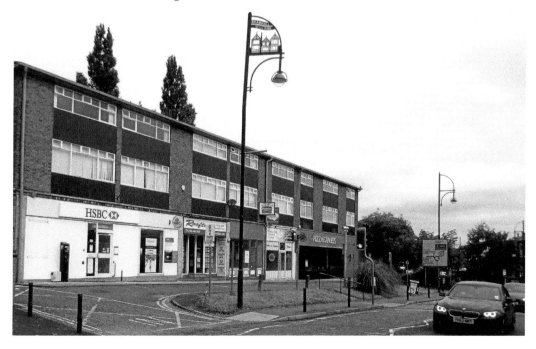

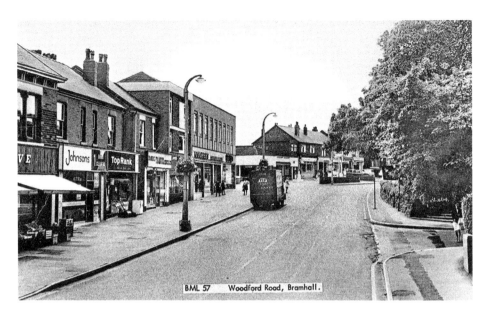

BML 57 Woodford Road, Bramhall.

Woodford Road

Here we see the view from further down the Woodford Road towards the village centre in 1971 and a view of the village from the inside of the Jasmin Café.

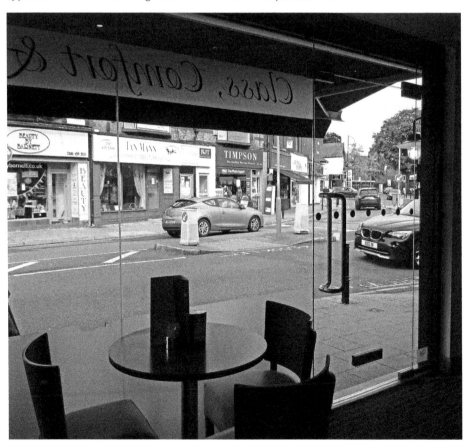

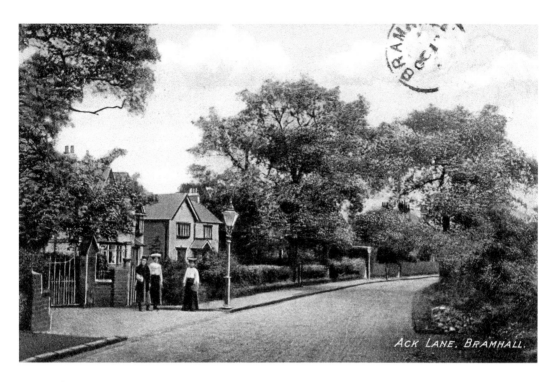

Ack Lane

A wonderful view of Ack Lane with elegantly attired ladies in 1909, and a classic shot of Bramhall in 1966 looking towards Lumb Lane on the right.

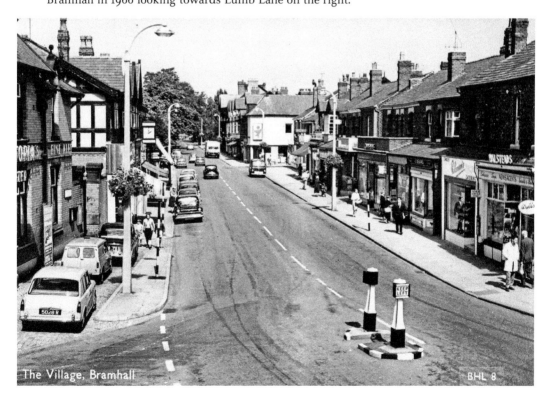

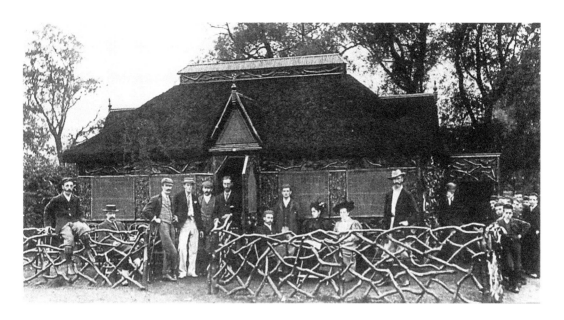

Bramall Park Golf Club – Naz, Sadia and Sam

The golf course here emanated from a meeting in 1894 of like-minded men to discuss the establishment of a golf course. Nine weeks later the club was opened and a nine-hole course was laid out at Ravenoak Road. The present club on Manor Road opened in 1923. The new picture shows local sport of a different kind with athletes from nearby Chorlton Runners leading the field in the Wilmslow Half Marathon in April 2016.

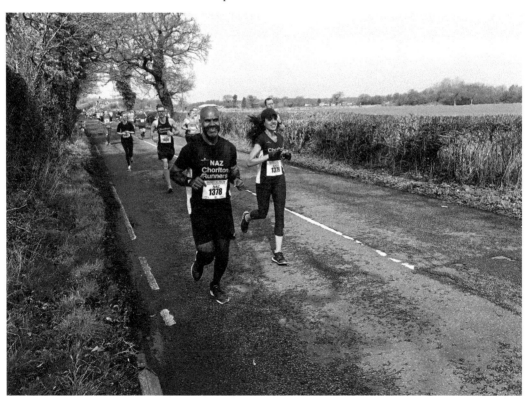

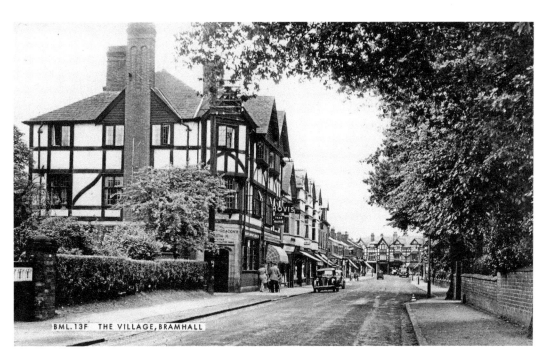

BML.13F THE VILLAGE, BRAMHALL

Bramhall Lane South

Looking down the road into the village centre. The old card was posted in 1965 but the photo was taken somewhat earlier, in the 1940s or 1950s.

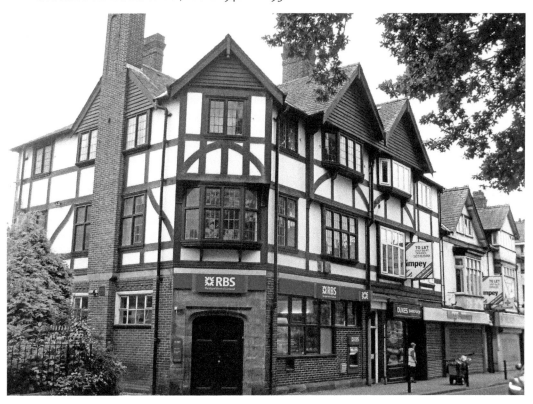

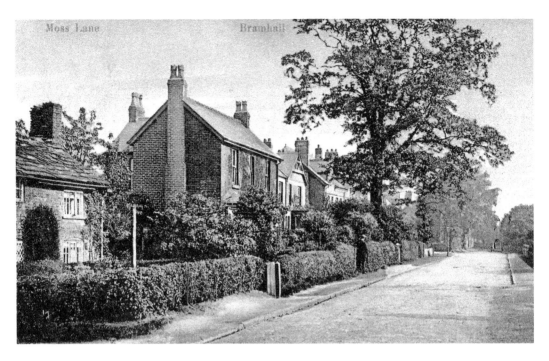

Moss Lane

Here, Moss Lane is seen in 1907 and today. The name comes from the Kitts Moss and the fact that up to the eighteenth century, the 49 acres of the Moss were divided into strips or moss rooms each around 30 metres wide and allocated to Bramhall tenants to cut peat or graze their animals.

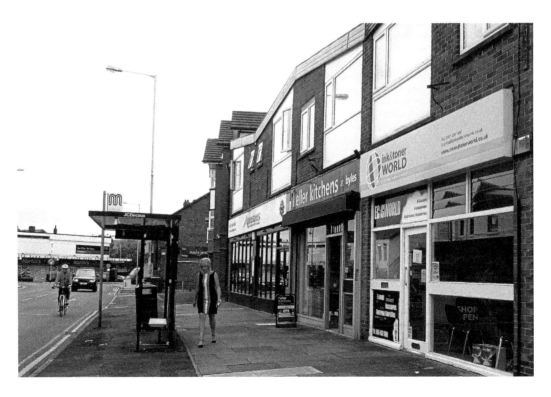

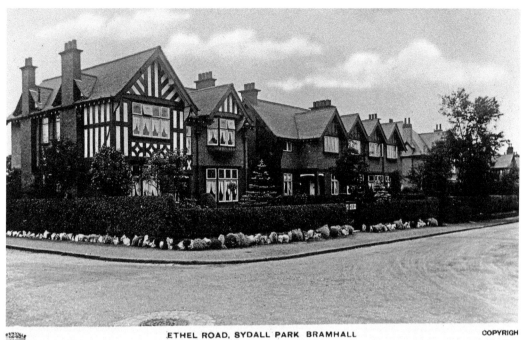

ETHEL ROAD, SYDALL PARK BRAMHALL COPYRIGH

Syddal Park

Bramhall village was formed from a cluster of hamlets which included Syddal, Pownall Green and Bramhall Green; it only really became a village after the station was opened in 1845.

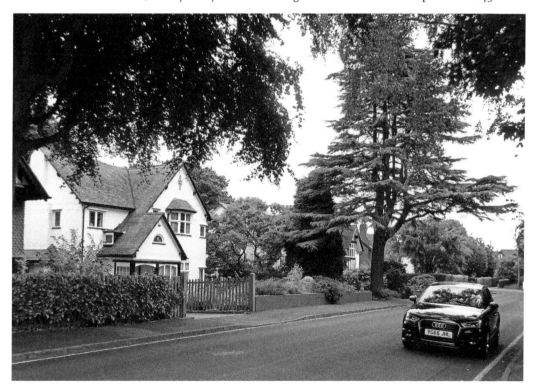

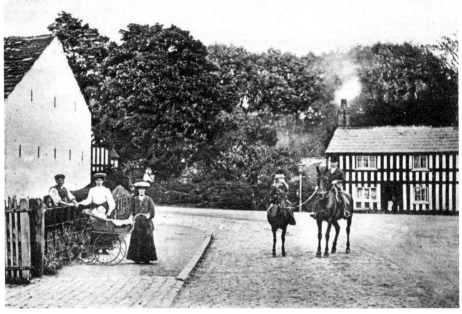

Bramhall Green

A quintessentially Edwardian scene showing Bramhall Green in 1910: fine hats, a perambulator, gas lamps and horse power.

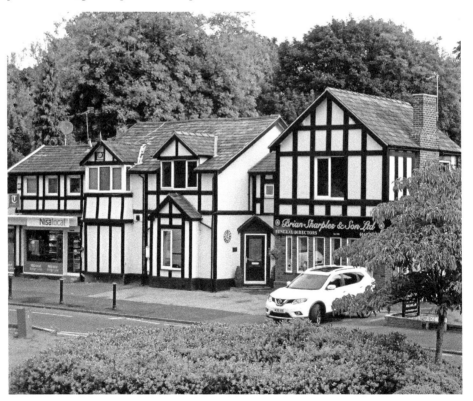

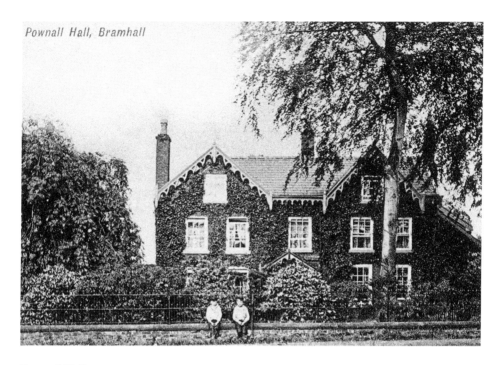

Pownall Hall, Bramhall

Pownall Hall

Pownall Hall in 1905; the Hall was at the junction of Bramhall Lane South and Ladythorn Road. It was demolished around 1970 and replaced by the Pownall Arms Hotel (later a Moat House), which in turn was demolished in 2008 and replaced by an old people's home, the Sunrise. The Hall boasted six rooms, including a parlour and a 'best room'. The Pownalls in the village go back to the fifteenth century and were later members of Dean Row Unitarian Chapel. Pownalls are remembered in *The Diary of Peter Pownall: A Bramhall Farmer 1765–1858* (1989). German POWs worked on the Pownall farm during the Second World War.

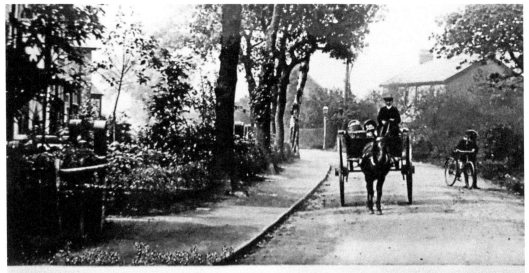

ACRE LANE, BRAMHALL.

Acre Lane, 1910

This post, by a former Bramhall resident in 2013, brilliantly sums up childhood life in the village in the late 1950s and the 1960s: 'Lived in Bramhall at 27 Maple Rd, opposite the Post Office ... I can remember every room in our house and could walk round the garden blindfolded ... There was the matinee at the Tudor, and sometimes a visit in the evening. Can anyone remember 'ratty Ruby' who would flash her torch at you and ssh you in the Saturday flics if you dared make a noise. Playing on the rec, tobogganing at Benja Fold, Brownies at the scout hut. Spent a lot of time in the garden of Hillbrook Grange the old folks home, some lovely people there and still remembered by me. My gran was the Matron there. Went to school at Pownall Green then down to Highfield for the last two years. Had a great teacher there, Mr Williams, Mr Fox was the headmaster, Mrs Wilde the infants' teacher and Mr Allport who emigrated to Australia. Also played in the park at Bramhall Park. When my mum was young ... all they could do was look through the gates and see the peacocks ... She went to school in what was the library just before the railway bridge.' Cath Mason (Gardner).

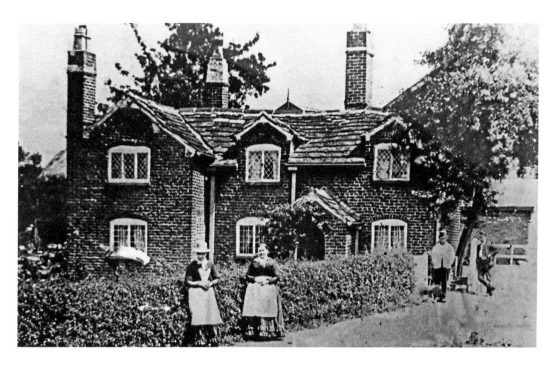

Hardy's Farm and Lumb Farm

Hardy's Farm in Ack Lane with Elin, Ada, Sydney, Frances and Joseph – the latter two being the sons of George Holland of Yew Tree Farm. A widow named Margaret Hardy was the farmer here in 1645. In 1822, Robert Hardy and three of his sons tragically died within six months of each other. The picture of Lumb Farm, off Lumb Lane, is from around 1890 when it was occupied by William Adkinson, the local builder.

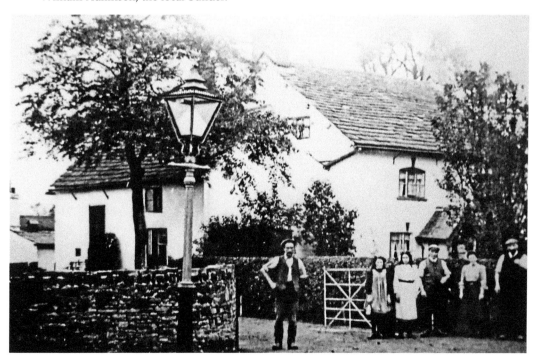

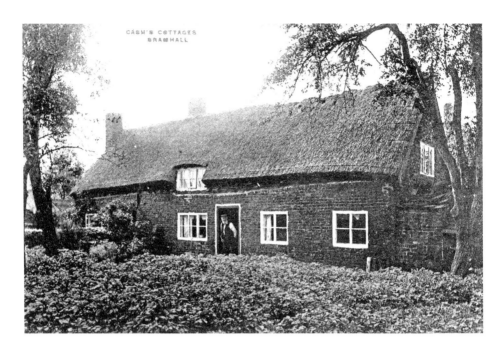

Cash's Cottages

These are in a hamlet that was known as Syddal, off Bramhall Lane, and named after the Syddal family who owned the largest house here in the late sixteenth century. The 1871 census reveals that one was occupied by John Redfern, his wife and six children, and the other was owned by the Cash family. Redfern was a silk weaver, shown here at the doorway. Cash was a blacksmith. The other picture is a row of cottages built in 1734 in Ack Lane.

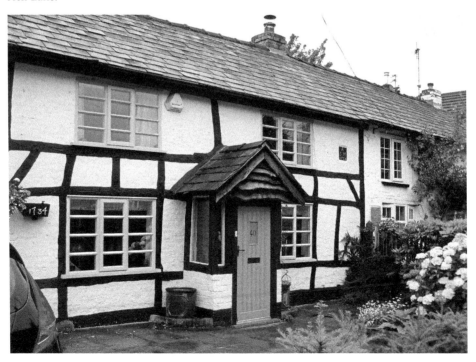

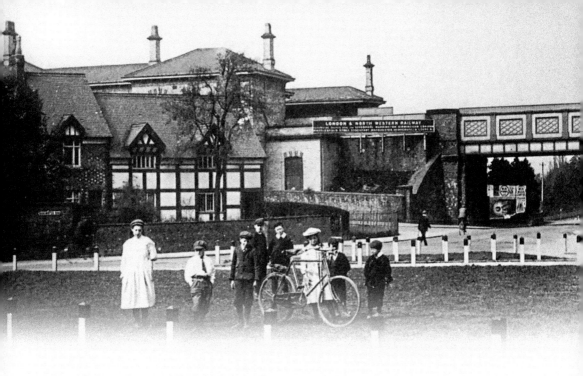

CHAPTER 2

Cheadle & Cheadle Hulme

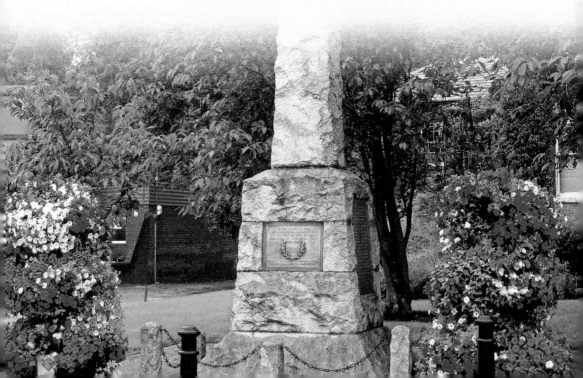

Cheadle Green and Schools Lane

The images on page 47 show Edwardian Cheadle Green with the manor house on the left and Cheadle Lower Station on the North Western Railways network. Note the size of the bicycle in relation to the children. The child on the far left is an amputee and may have been a patient at the Barnes Hospital nearby (*see* page 58). The war memorial is in the lower picture. School Hill at the junction with Wilmslow Road is on this page. The school referred to is Lady Barn School – one of England's top independent primary schools that was founded in 1873 by W. H. Herford, an educational pioneer, Unitarian minister and one-time tutor to Lord Byron's grandson. Herford founded his school on the innovative principles he had experienced in Switzerland and Germany and was also one of the first educationalists to advocate co-education, a kindergarten for pupils under six and to reject the brutal methods practised in some Victorian schools.

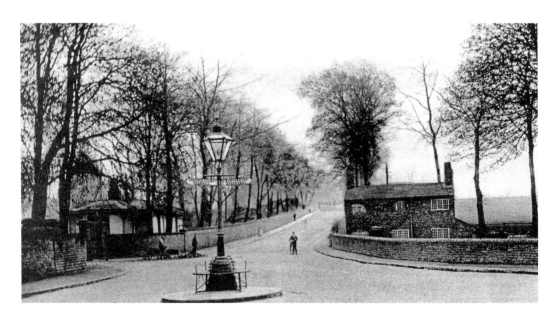

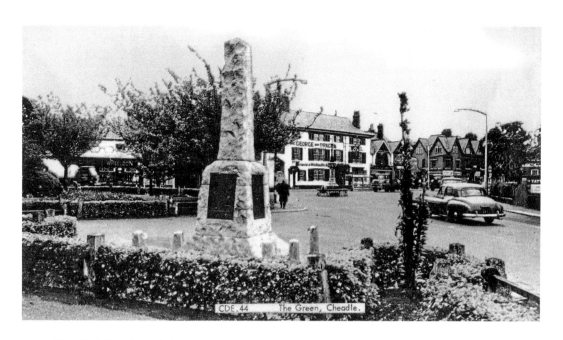

Cheadle War Memorial
Etched onto the monument are the names of 101 men from Cheadle who died in the First World War. Fifty-four Second World War casualties have been added to the memorial. The names of eight local air-raid victims are also listed.

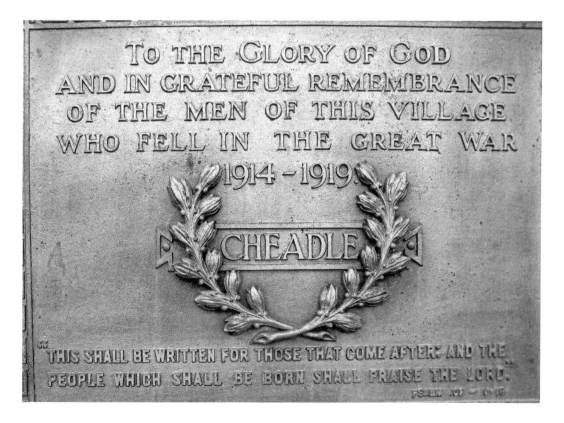

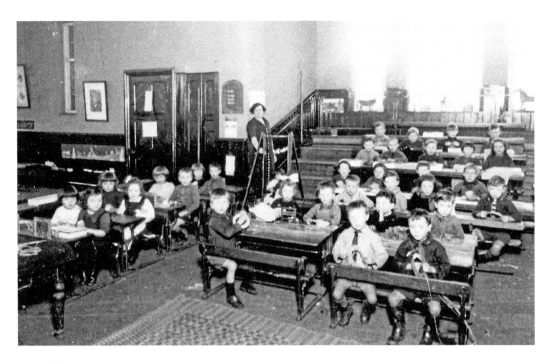

Councillor Lane Primary School Class
Councillor Lane Primary School once stood where Ladybridge Primary School has been since it opened in 2002. The school enjoys resourced status, which means that it includes pupils with severe, complex and profound multiple learning difficulties. The lower picture shows a class of National School pupils in 1912.

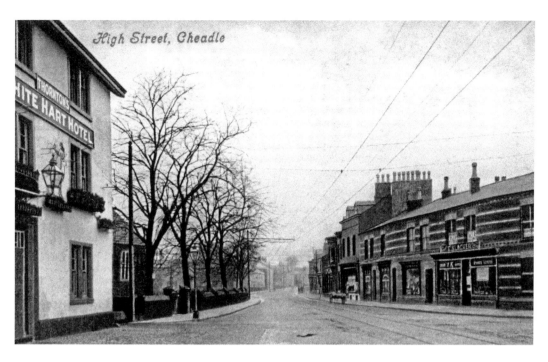

High Street, Cheadle

The White Hart and Cheadle Bridge
The bridge was built in 1861 and crosses the River Mersey on the Manchester Road (B5095) between Cheadle and East Didsbury. The Gatley Road toll gate was next to the White Hart.

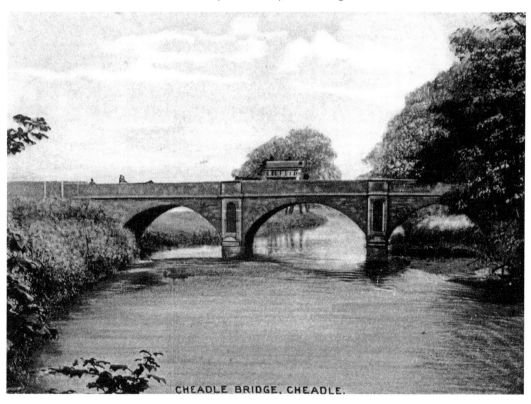

CHEADLE BRIDGE, CHEADLE.

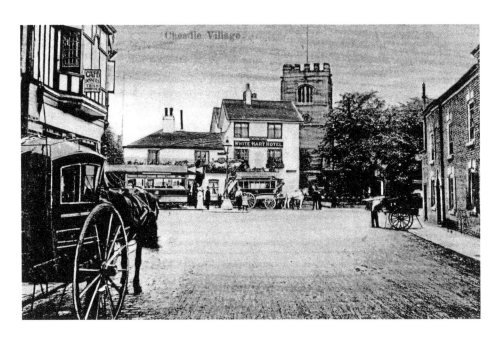

The White Hart and St Mary's Church

The Stockport to Gatley tram ran down here. Saddler John Donald's sister made a life-saving decision when she she made a last-minute decision not to travel on the *Titanic*'s maiden voyage. The Electra Cinema was in the High Street too. A church has stood on this site since at least 1200; the present church dates between 1520 and 1550 and has been the subject of many restorations since then. The churchyard contains the war graves of three First World War soldiers.

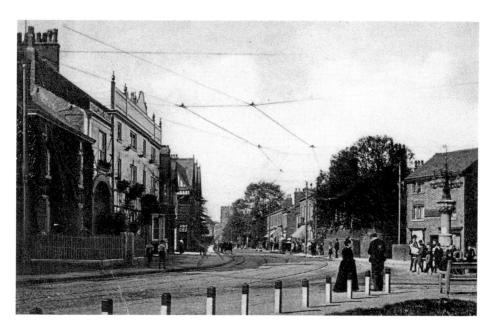

Cheadle High Street and the Star Inn

Other well-known traders included T. Seymour Mead, grocers; Needhams Fruiterers; the Arcade; Heald's, and the grocers John Williams on the corner of Massie Street; John Donald, saddlers famous for their horse blankets and harnesses; and Alcock's outfitters.

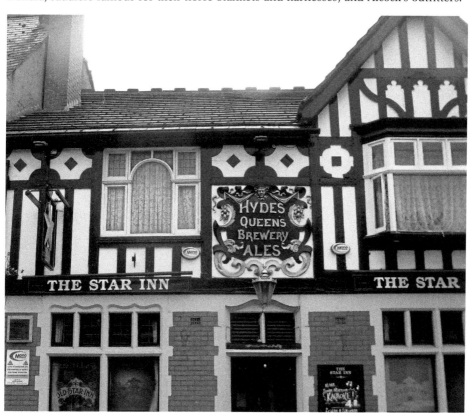

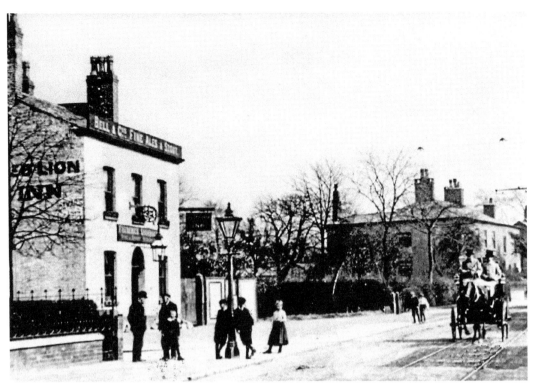

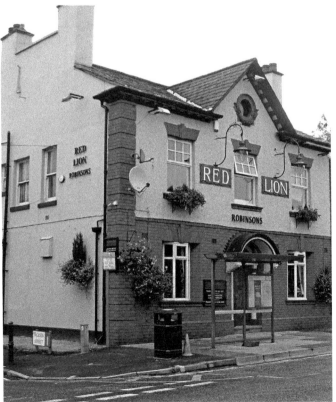

The Red Lion

The Red Lion, on Stockport Road, was once a Bell's Ales house, as the sign shows. Silk weaving apart, other local industry included a corn mill open until the First World War, cotton weaving and a brickworks.

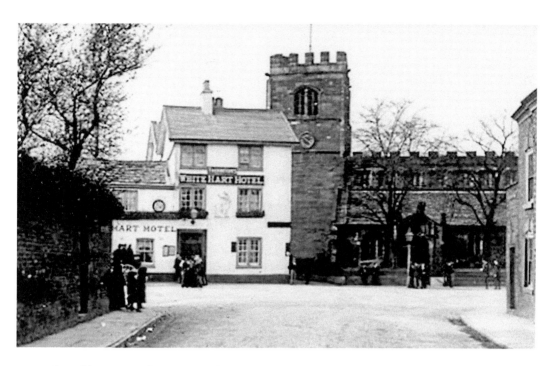

The White Hart and St Mary's Church
St Mary's Church is in the background. Horse-drawn buses ran from here to Manchester. To the left was the rectory wall and the National School is on the right. The clock on St Mary's, installed in 1988, bears some intriguing messages. On the south, porch side, the inscription reads 'Forget not God'; on the west, White Hart side, 'Trust the Lord'; and 'Time in Flying' on the east.

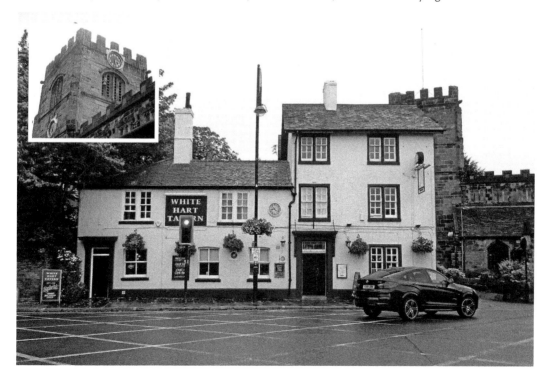

Cheadle Green and the George & Dragon
The George & Dragon is a Grade-II listed late eighteenth-century coaching inn. The mock Tudor façade was a later addition. The bowling green sign does not indicate another pub next door, but the entrance to the George & Dragon's bowling green. Cheadle's most famous pub sign is outside the George & Dragon; it was designed in Wilmslow in 1842 and then cast in Sheffield before being erected outside the then coaching house and has been there ever since.

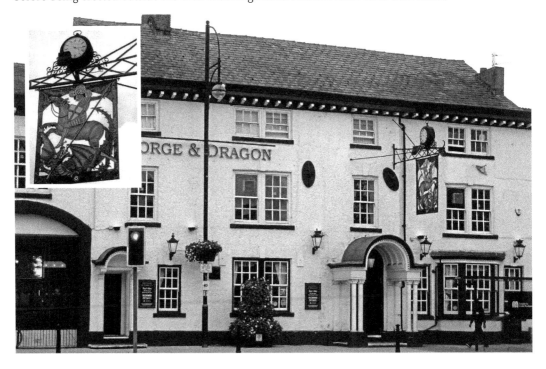

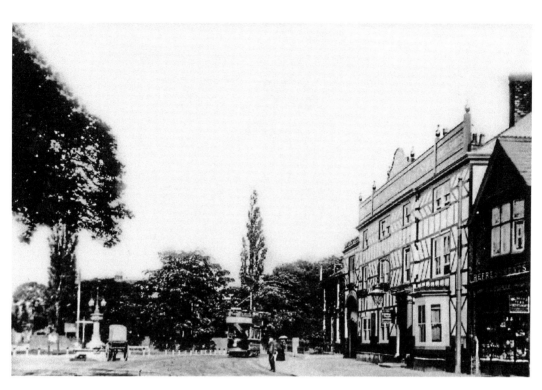

Cheadle High Street

Looking west, the lower shot shows the impressive way the George & Dragon owners have converted the former coaching archway, incorporating it into the pub by glazing it front and rear.

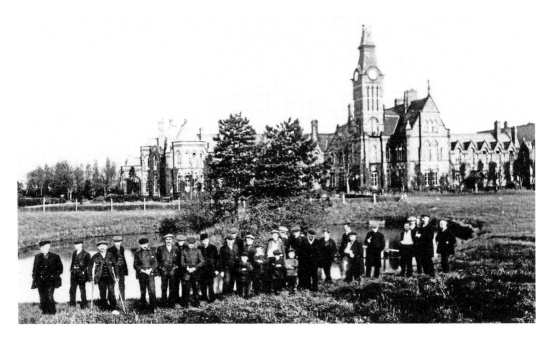

Barnes Convalescent Home

Patients from the convalescent home that was the Barnes Hospital, celebrating on gala day in the 1910s. Situated on Kingsway, the former hospital closed in 1999 and is now derelict, although the main French Gothic Revival building is Grade II listed; it is marooned in a sea of roads and is currently being converted into flats. The hospital came into being when Manchester Royal Infirmary sought a convalescent home on the outskirts of the city, where the air was smog-free. During the Second World War, the hospital cared for injured and traumatised soldiers. In its latter days it was a centre for geriatric care and stroke patients. Described by Nikolaus Pevsner as 'large, Gothic and grim', it has formed the set of many a horror movie. The modern photograph was taken in 2008 by Mike Peel (www.mikepeel.net).

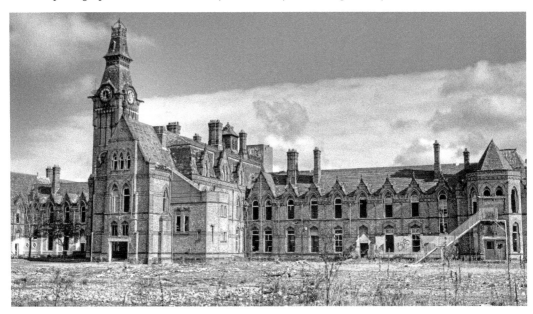

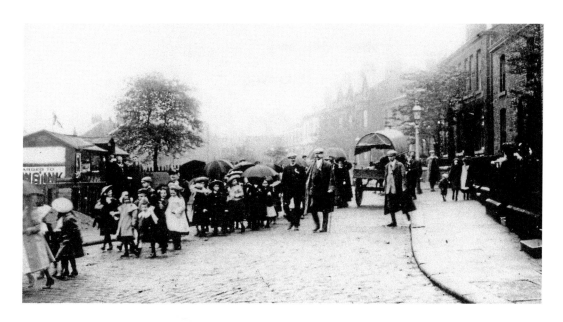

Orphan Homes Gala Procession

The above image shows the Orphan Schools gala procession. Today's Cheadle Hulme School has its origins in the Manchester Warehousemen and Clerks' Orphan School. This was founded in 1855 when its original intake was made up of orphans. It started off in Shaw Hall, Flixton, moving to Park Place, Ardwick in 1861, and to its current location in 1869. The school was named 'The Manchester District Schools for Orphans and Necessitous Children of Warehousemen and Clerks', open to all fatherless children, regardless of gender or religion. Fees were one guinea per annum, doubling only in the 1950s. During the First World War, the school hospital was taken over by the Red Cross treating over 1,400 injured soldiers. In the Second World War, students from Manchester High School for Girls and Fairfield High School for Girls Droylesden were evacuated here. Sixty Old Waconians died in the First World War and forty-six in the Second World War. In 1931, the name changed to Cheadle Hulme School.

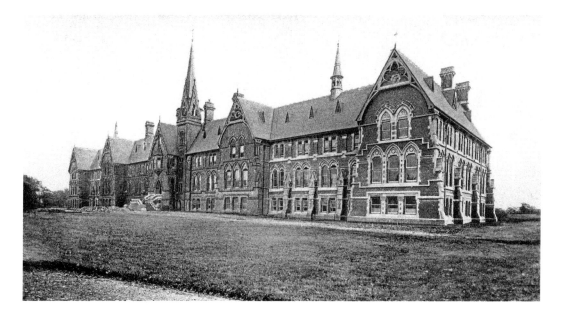

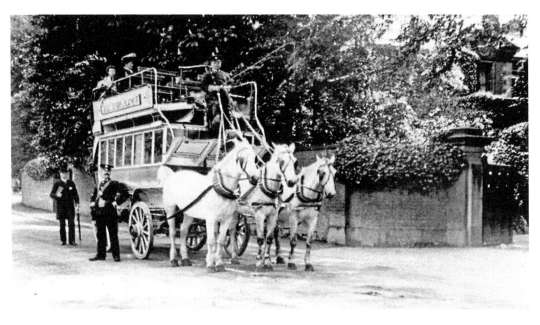

The High Street in 1900

Here the lower image is looking towards Cheadle Hall. The upper image shows the Cheadle–Manchester horse-drawn bus; note the splendid near-identical horses. One of the features here was the Red Cap School – named after the boy's uniform.

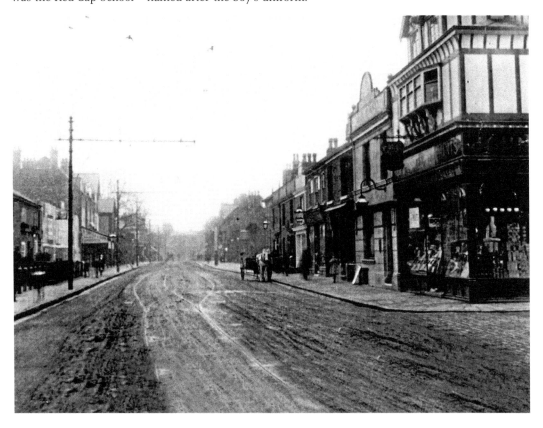

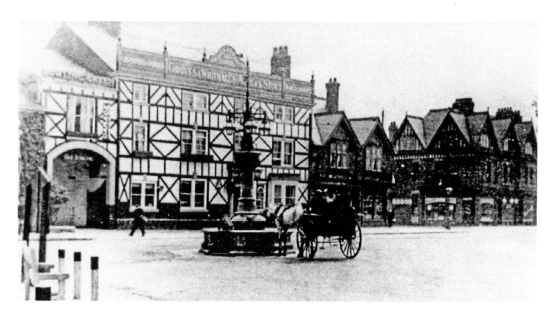

Ockleston Memorial Fountain

Dr Robert Ockleston practiced as a hightly respected doctor in Cheadle for most of the latter half of the nineteenth century and lived in a house on the north side of High Street. See the horses slaking their thirst in the trough. As well as horses, dogs and children drank their fill here. The fountain was moved in 1968 to Queens Gardens where it remains to this day.

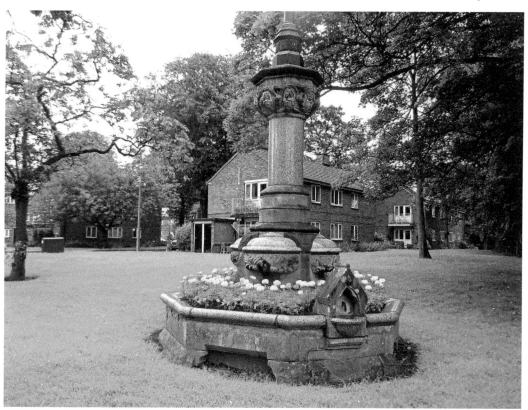

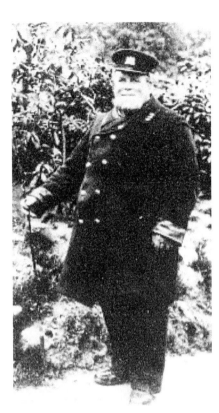

Scotch Bob

Scotch Bob was James Telford, an ebullient man born in 1857 who came from Canonbie, Dumfriesshire. By the time he was fourteen, he had settled in Cheadle and by 1879, he was driving a large red horse-drawn bus for the Manchester Carriage Company. He sometimes drove three horses abreast, always quoting Robert Burns along the way. When he reached the age of fifty-six, Bob had travelled a record-breaking 937,000 miles along just one route between Cheadle and Manchester. He died in 1929 and is buried in St Mary's churchyard behind the White Hart stables. The marvellous wooden statue on the Green was carved by sculptor Andy Burgess.

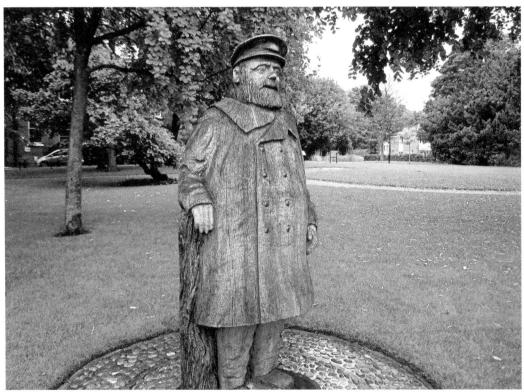

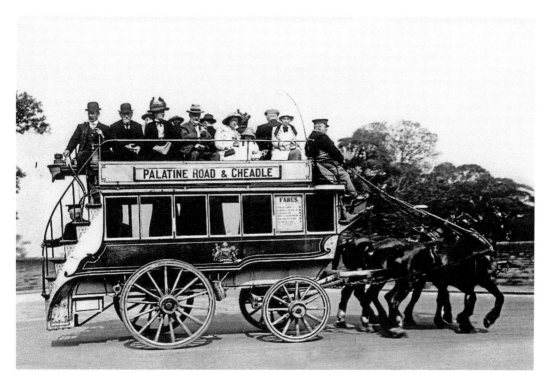

All Aboard for Palatine Road (with Scotch Bob)

The upper image from 1913 shows the final journey of Boswell's horse-drawn bus that operated between Cheadle and Manchester. The bus could carry up to thirty passengers, with twelve perched on the cheaper seats on the roof. Scotch Bob was very much in control.

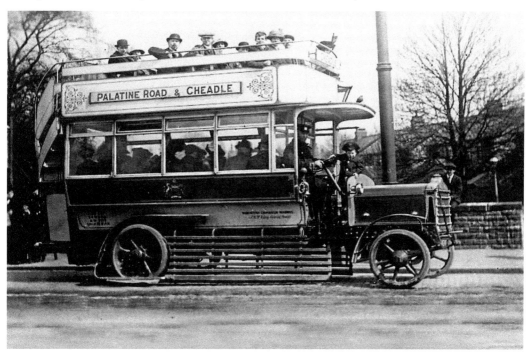

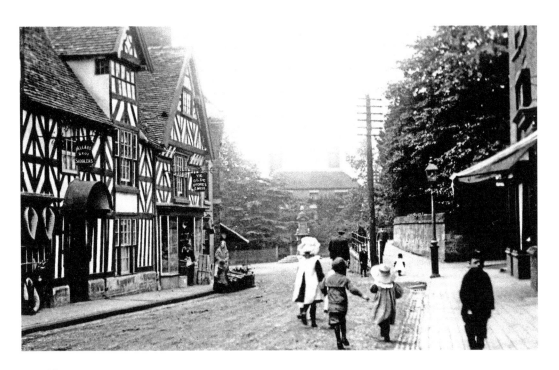

Ye Old Stores

Ye Old Stores is furthest away on the left owned by Mr Moss with saddlers J. A. Allard nearer the camera. The modern picture is of the High Street viewed through St Mary's lych gate (from Old English *lic*, meaning 'corpse'). The Grade II-listed lych gate was erected in 1883 in memory of Colonel J. H. Deakin. During the Second World War, Cheadle Hulme took in evacuees from places as far apart as Manchester and the Channel Islands.

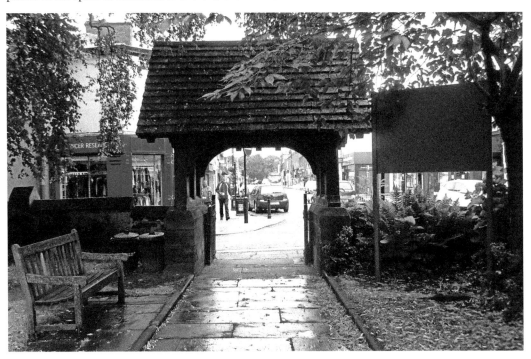

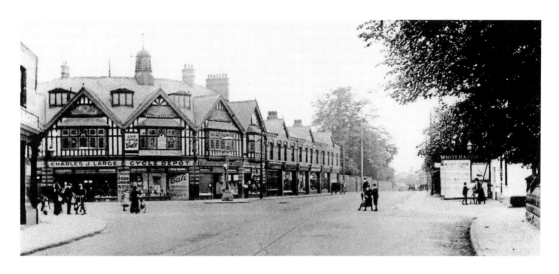

Gatley Road

The impressive Tudor-façade building was then known as Burgon's Buildings after the original cycle store, later, as here, Charles J. Large, with Cosy Café and grocery shop below. There were two devastating air raids on Cheadle during the Second World War. The first was on Christmas Eve 1940, when a 1,000-lb bomb from a German bomber targeting RAF Handforth (then engaged in manufacturing aircraft wings) crash-landed on a house in Bulkeley Road. The second raid was on 4 February 1941, when a lone bomber hit a house on Stockport Road, killing a mother and her daughter and injuring a fire warden, who died the following day.

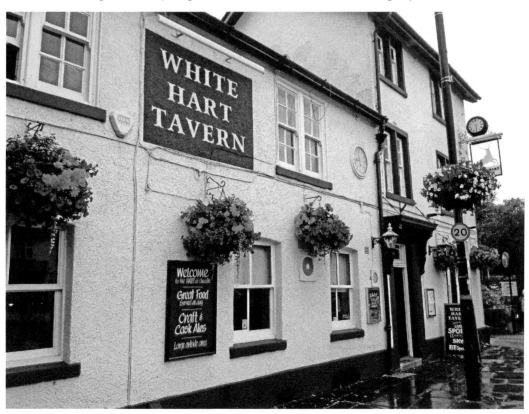

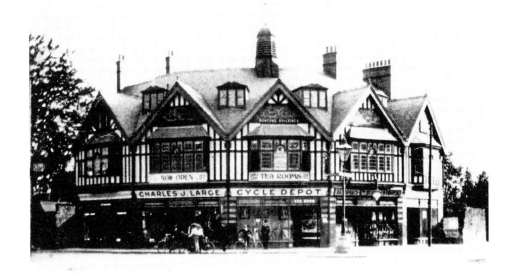

Weavers Store

This indicates the weaving heritage in the locality. There is evidence from excavated Roman coins in the vicinity long before this. During the seventh century, St Chad preached here, indicating an Anglo-Saxon presence; a stone cross dedicated to him was found at the confluence of the River Mersey and Micker Brook in 1873, an area which became known as Chedle, a corruption of Chad Hill.

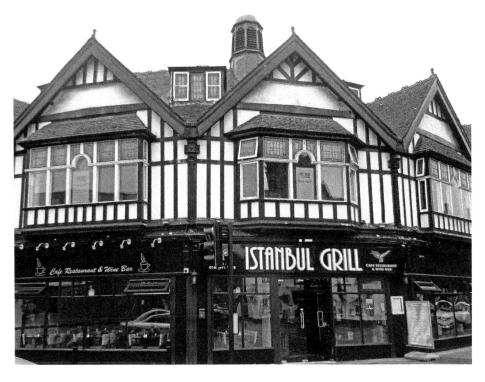

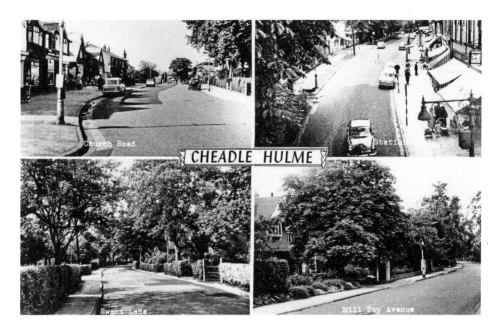

Cheadle Hulme

In 1294, Geoffrey de Chedle was lord of the manor of Cheadle; his descendant Robert died in the early 1320s and left the estate to his wife Matilda, who held it until she died in 1326. There were no male heirs to the manor so it was divided between her daughters, Clemence and Agnes. Clemence took the southern half (later the modern-day Cheadle Hulme), and Agnes inherited the northern half, (Cheadle). The two areas were known as 'Chedle Holme' and 'Chedle Bulkeley' respectively. Cheadle Hulme is slightly unusual because it did not grow around a church like the typical English village, but instead emerged from several hamlets, the names of which survive in Smithy Green, Lane End, Gill Bent, and Grove Lane and in the names of schools such as Orish Mere Farm and Hursthead Farm.

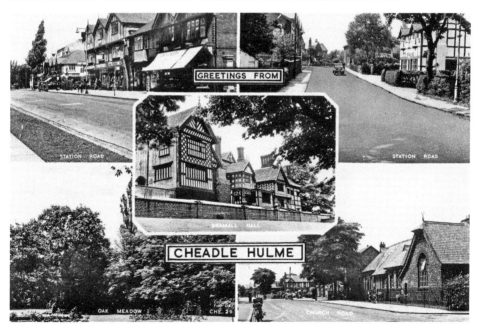

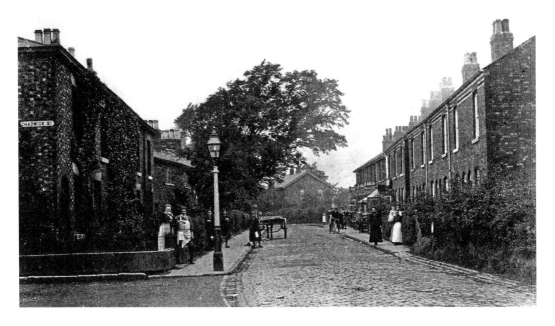

Hulme Hall Road and RAF Handforth

The cottages in the new photograph are called Smithy's Cottages. Cheadle Hulme is famous for being one time home to RAF Handforth – a huge universal stores depot operating under the name 'RAF Handforth No 61 MU (maintenance unit)'. It stored everything from cups and saucers to aircraft engines and was served by an internal railway system with its own shunters and an engine shed.

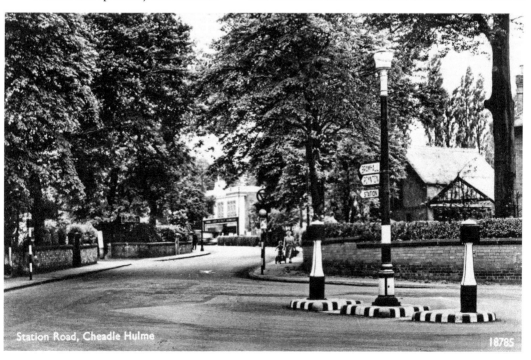

Lollipop Train Disaster

The train involved in the Cheadle rail crash was carrying 234 school children and teachers from Gnosall in Staffordshire when it came off the rails at Cheadle Hulme station at 9.40 a.m. on 28 May 1964. Three people died, including two children, and twenty-seven were injured. A Ministry of Transport investigation found that the train was being driven too fast. The *Stockport Advertiser* reported that Cheadle Hulme became a 'village of horror ... and heroism' as people rushed to help the injured children.

Station Road, Cheadle Hulme

18785

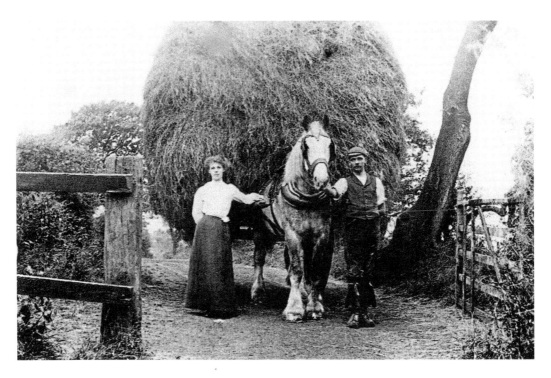

Cow Lane in 1901

Oliver Davenport with his wife and his horse in Cow Lane (now Ramillies Avenue), Cheadle Hulme. Cow Lane began where Grosvenor Street ended; they are on their way to Old Fold Farm, once known as Locker's Fold. In 1925, on this death of his father, James, Oliver took over the tenancy of the farm on Gill Bent Road. The farm was demolished to make way for housing after the Second World War. The lower image shows Mellor Road in 1905, looking towards the station and its footbridge. The shop (No. 12) on the left next to the gas lamp is the post office, run by Mrs Catherine Potts; at No. 6 with the striped canopy we have Mr Chiverton, the drapers and next to him at No. 6, the fruiterers run by Thomas Moss.

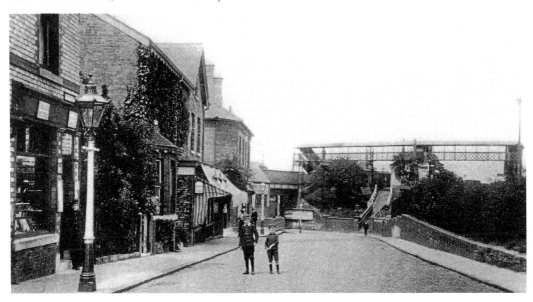

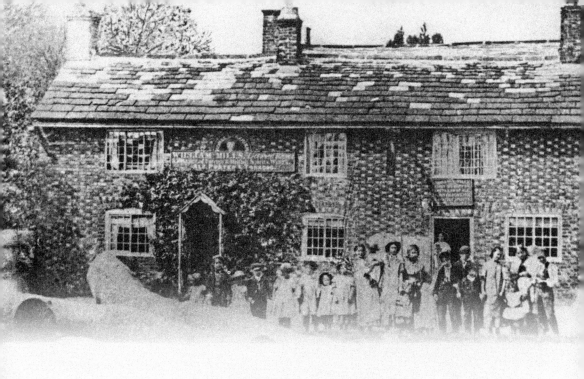

CHAPTER 3

Gatley

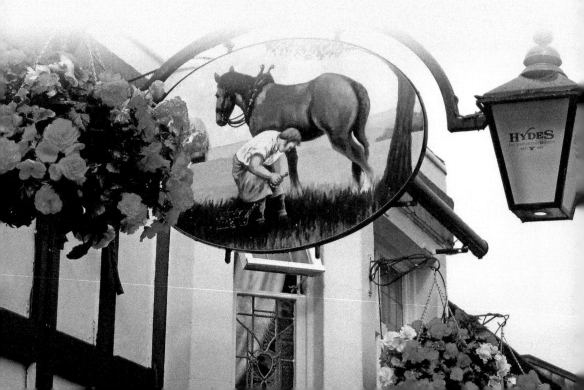

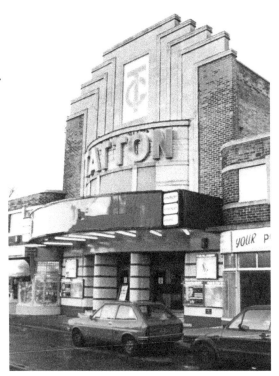

Tatton Cinema

A sorry tale of dilapidation and dilatoriness leaving Gatley for fifteen years with an eyesore that seriously mars an otherwise pleasant and attractive village. Only the magnificent art deco facade remains of the cinema, which was originally built in the 1930s and closed in early 2001. Years of delays have seen (locally opposed) plans for redevelopment including supermarkets and residential buildings come and go, and compulsory purchase orders not carried through.

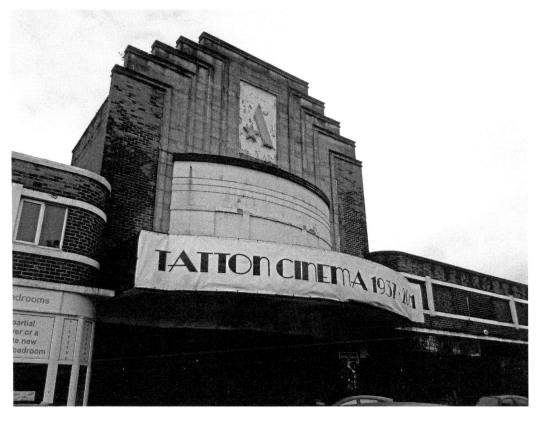

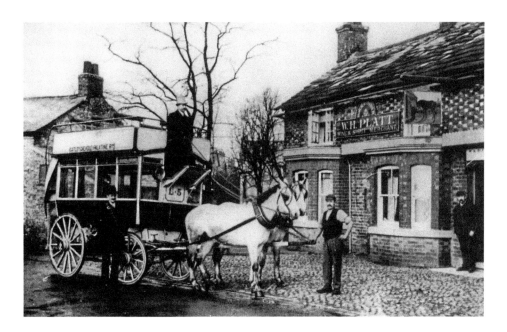

The Horse & Farrier

Seen here and on page 71, this photo of the eighteenth-century hostelry was shot around 1875. It was originally owned by the Tattons of Wythenshawe Hall and formed part of a marriage settlement when Thomas William Tatton married Harriet Susan Parker in 1843. The second Red Lion here was and remains on Church Street; it closed in 2009. In the early 1980s the pub was renamed as the Bitter End, unfortunately prophetic given its closure. The first Red Lion on the site dates from the eighteenth century; its original name was the Crown Beerhouse. There were two cottages to the rear, one of which was occupied by a Mrs Wood who kept a stocking knitting machine in an outhouse selling her wares in the cottage-shop. She was nothing if not enterprising – when George V fell off his horse and injured his leg, she knitted a stocking for him, lined with comfrey for the pain. She received a thank-you letter from Buckingham Palace, which she displayed proudly in her window with a sign proclaiming 'By Appointment to the King'.

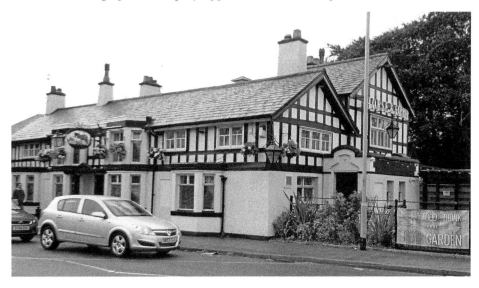

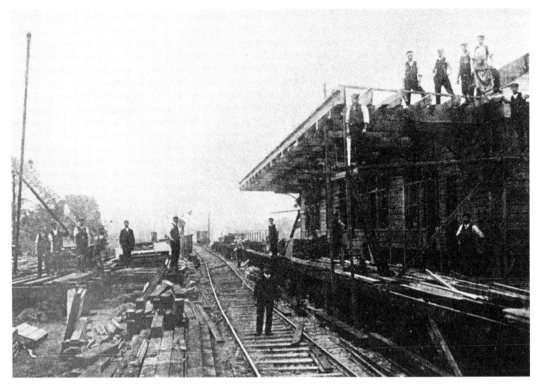

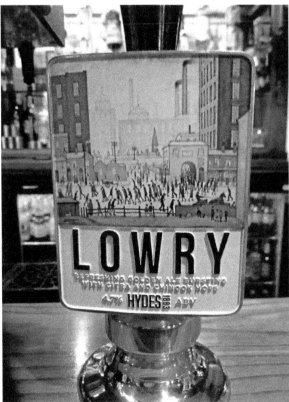

Gatley Station

The above image shows the station being built in 1908. Opened by the London & North Western Railway in 1909, it was for many years known as Gatley for Cheadle before being renamed Gatley in 1974. The lower image is one of the hand-pump clips in the Horse & Farrier. The Lowry image is 'Coming from the Mill' (1930). It is the second from Hydes' range of L. S. Lowry themed beers launched in 2016, this one branded as 'Dispute'; the first was 'The Mill'.

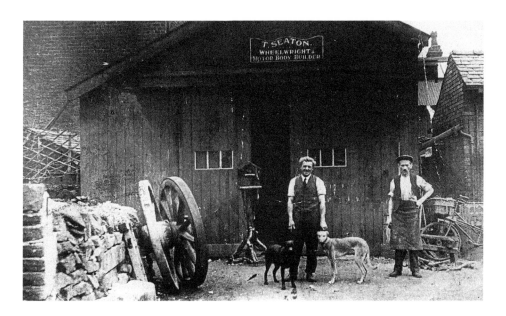

Spinning Wheels

Interesting professions, trades and crafts in Gatley included basket making in the sixteenth century; button man, fettler of bells, midwife and webster (weavers) in the seventeenth century; badgers and chapmen (travelling salesmen), button man, clockmaker, cotton manufacturer, fustian cutter and staymaker in the eighteenth century; beaverine factory (a type of velvet), botanical anatomist, brickmaker, dressmaker, dyer, fustian cutter, governess, lamplighter, milliner, nurse, pipemaker, schoolteacher, silk manufacturer, sugar boiler and teamsman in the nineteenth century. The wheelwright in the lower picture is Cash's, taken around 1886 on the Styal Road. There was a Gatley blacksmiths in 1600, Robert Watt; one in 1790, Robert Downs; and four in the nineteenth century, Joseph Albison (1851); members of the later Downs family (1841–51) and John Jenkinson (1841). The Swans were blacksmiths and farriers and are pictured here in 1898; their forge was at the junction of Brownlow Green, Crossacres Road and Woodhouse Lane. The photo shows four members of the Swan family, including Mrs Swan.

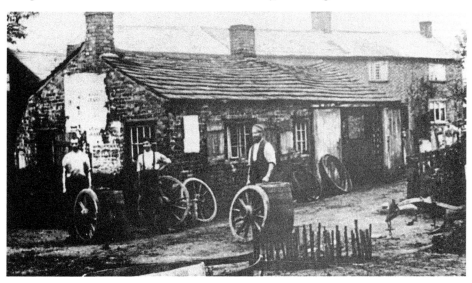

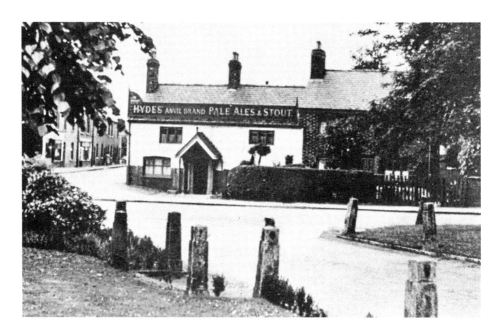

The Prince of Wales

This photo was taken just after 1947 but earliest definite records date to 1887, when Mary Moult was the 'beer retailer'. In 1856, a Daniel Moult is recorded as having a beerhouse in Gatley – presumably at the Prince of Wales since Daniel was Mary's husband. It is quite possible that ale was sold on the premises as far back as 1779, when an alehouse licence was issued to an Esther Wood. The cottage to the right of the pub was swallowed up by the pub in a 1952 refurbishment.

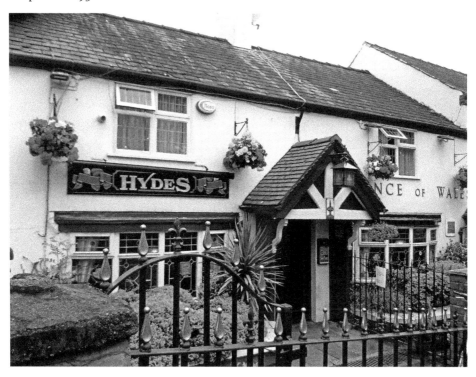

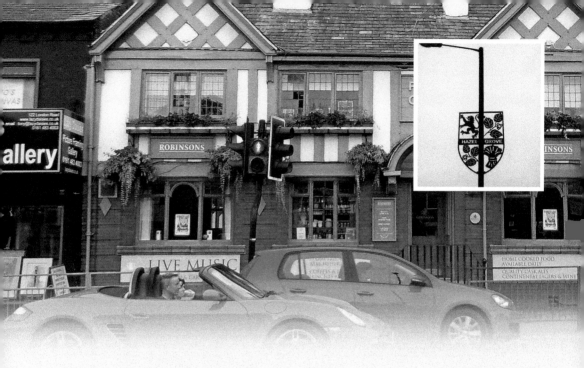

CHAPTER 4

Hazel Grove or
Bullock Smithy

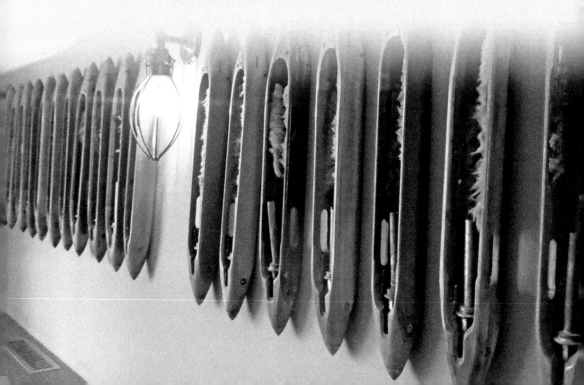

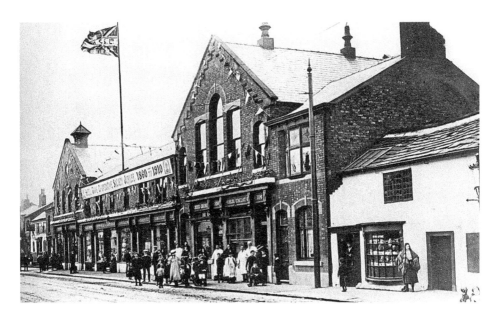

The Co-Op

London Road and the start of Buxton Road in Hazel Green are home to many pubs, as will become apparent over the next few pages. The Flying Coach (pictured on page 77) was originally called the Cock Hotel and before that the Game Cock. A recent refurbishment has produced a tastefully designed and decorated pub with some interesting paraphernalia relating to the area's textile industry heritage. Apart from the striking row of loom shuttles, there are old elixir bottles, a hand-painted version of the Flying Coach's new logo and a library. The new name recalls the fact that the pub was once a coaching inn, like many others along this road, on the Manchester to London route. Fiftieth anniversary celebrations under way at the Hazel Grove Industrial and Equitable Co-op Society on 30 July 1910. The inset shows the magnificent mosaic on the old Co-op building on Stockport Road, Cheadle.

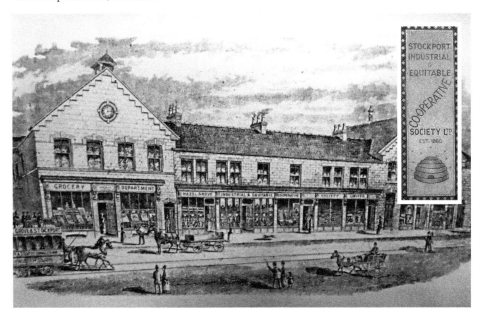

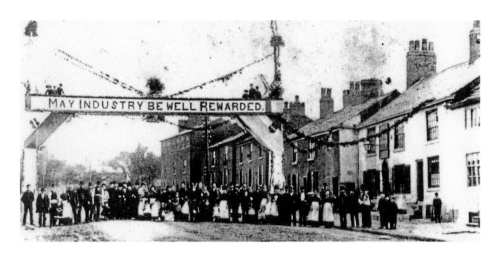

The A6 in 1866

The rough and rutted A6 shown as it was in 1866, when the villages took to the streets to celebrate fifty years of not being called Bullock Smithy. The lower image shows some random advertising spoiling the wall of the Bird in Hand, which was originally called the Plough. Appropriately enough, the pub was the regular meeting place for local pigeon fanciers, and for the Botanical Society.

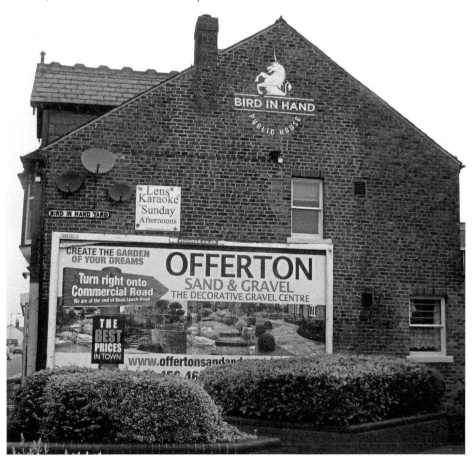

The Rising Sun

This is the first pub you come to on leaving the London Road on the way out of Hazel Grove. The 1890 *Directory of Cheshire* describes Hazel Grove as 'an irregularly disposed line of dwellings on either side of the road leading from Stockport to Macclesfield'. It goes on to say that the name of the place was changed in 1836 to its 'more euphonious appellation'. Silk weaving, cotton weaving, hat manufacturing and coal mining are named as the occupations of the inhabitants. The Rising Sun is at the junction of the Buxton–Manchester and Macclesfield roads. It was a posting house run between 1815 and 1860 by John Upton. He must have been a busy man because he was also a vet and a victualler.

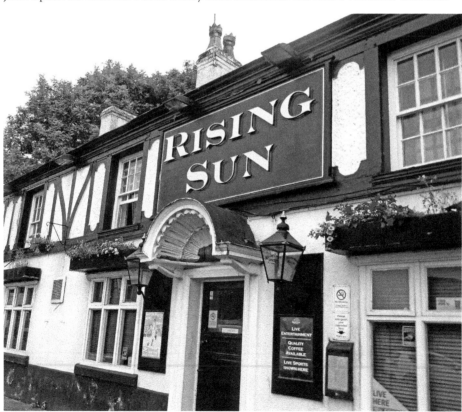

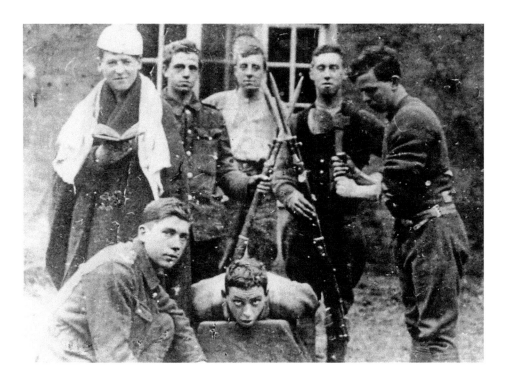

Arthur Lees

Seven soldiers of the First World War from Hazel Grove, including Arthur Lees (second left at the back), participating in a sham decapitation. The website on which this photograph appears (www.oldukphotos.com/cheshire-hazel-grove.htm) tells us that Arthur married Eva Smith of Atherton in the summer of 1921; he was by then employed as a tram conductor with Stockport Corporation Tramways. The photograph is from the collection of Tim Lees – grandson of Arthur and Eva, and son of Wilfred Lees. The lower image is of a handloom weaver at work.

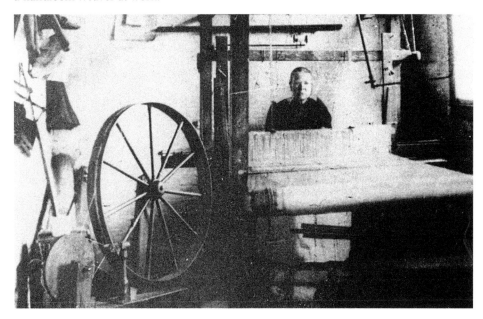

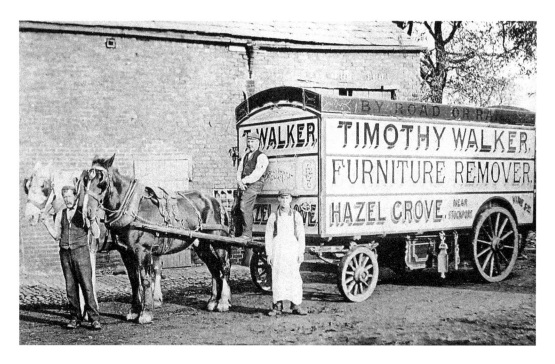

Timothy Walker's Horse

Timothy Walker's horse-drawn removal van in around 1910; although his stables were in Vine Street, he lived at No. 47 Hazel Street and was also known as a coal dealer. A local modern equivalent is in the lower image: a 1999 Scania 94D 220. By 1824, the following pubs were serving: the Anchor; the Queens Head; Red Lion and Posting House ;the Bulls Head; the Three Tunnes; the Hazel Grove; the Fox & Goose; the Cock; Rising Sun Inn and Posting House; the Grapes; the Crown; Dog & Partridge. Thankfully, but unusually, many survive.

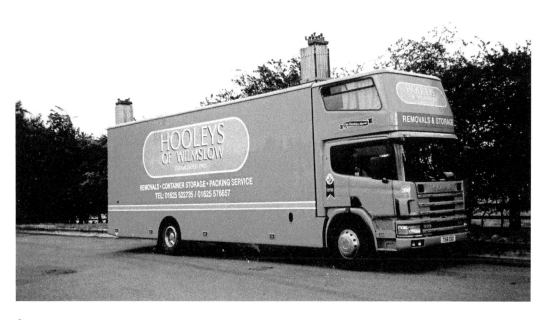

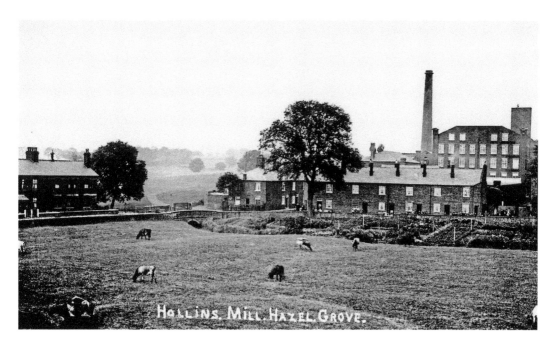

Hollins Mill Hazel Grove.

Hazel Grove Trade and Industry

On this page we have two examples of the area's industrial heritage: Hollins Mill and Park Pit, Poynton. Hollins Mill was one of a number of other cotton spinners and manufacturers in the vicinity. The earliest records for coal mining at Poynton go as far back as 1589. The collieries closed in 1935 with 250 redundancies. Apart from Poynton, there was Norbury Pit on High Lane, and a small pit behind the Rising Sun. Coal was sent to Stockport and to Macclesfield by way of the canal, which opened in 1831.

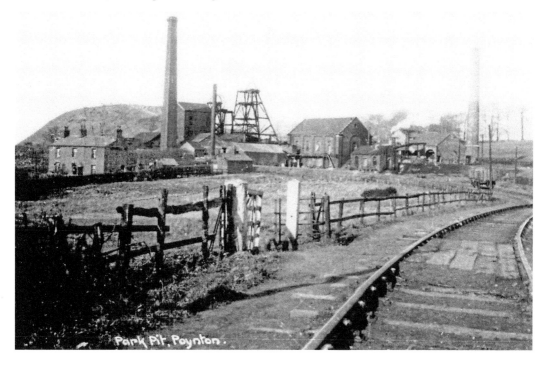

Park Pit Poynton.

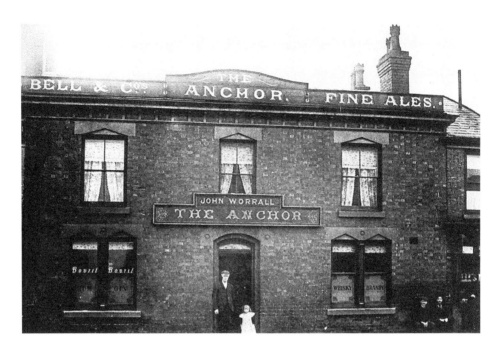

The Anchor and the Bird in Hand

The pre-1818 Anchor was previously called the Rope & Anchor and was home to the annual Celery Show in the second half of the nineteenth century. The show, which featured many other fruits and vegetables, was followed by 'supper and a convivial evening'. Like other pubs, The Anchor brewed its own beer. 'Bird in Hand' refers to the bird sitting on the left gauntlet in falconry – as depicted on this striking sign.

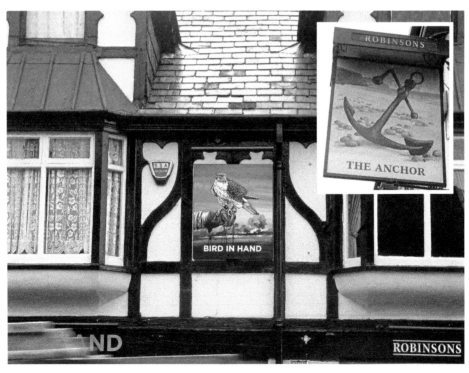

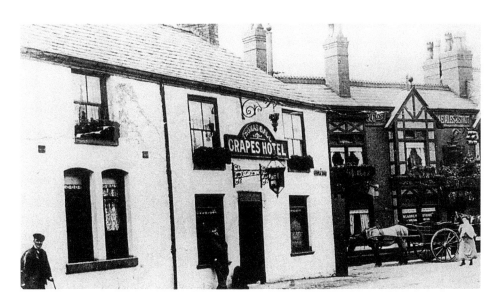

The Grapes and the Three Tunnes

The Grapes was first licensed in 1795, when it was a thriving farm; the Three Tunnes is next door. Surprisingly, the Grapes is in Norbury while the Three Tunnes is in Bramhall; the Horse & Jockey just down the road is in Bosden. Other nearby pubs included the Old Fox, also known as the Fox and Goose Inn, and the Red Lion Hotel. This opened in 1796 as a posting house for the mail coach service with stables and bowling green to the rear. The aptly named Fidler family ran the hotel before 1754 when they illegally leased the common land in front of the hotel, Fidlers Green. They were able to pocket the proceeds from five cottages, two loom shops, a blacksmith, and pig sties and shippens (cowsheds). The Enclosure Act of 1811 put an end to all that. There was a balcony at the rear overlooking the bowling green, and rumour has it that the pub was once called the Bees Knees.

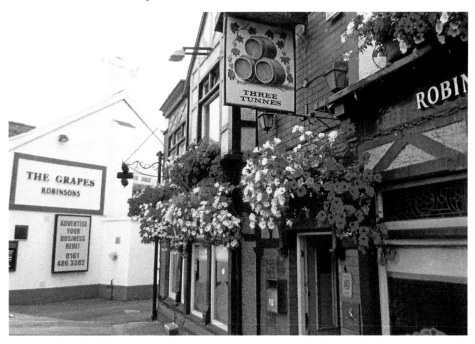

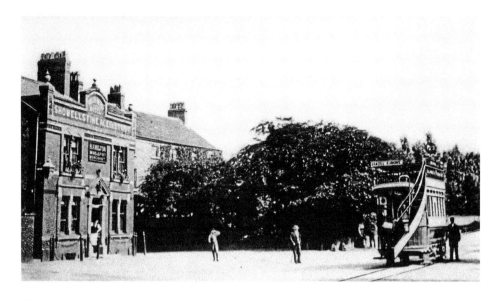

The Bull's Head

Opposite the Bull's Head (opened 1812) was Torkington House, where Gaskell's silk mill used to be. Gaskell's was Hazel Grove's first silk mill; Samuel Gaskell is shown in records of 1813 as a check or muslin manufacturer. The Hazel Grove silk mill was at the top end of the village, and called 'the Top Shop' as a result. The first cotton factory was opened by Henry Marsland in 1761 in Bosden for hand spinning and loom weaving. 'Carriers' fetched the work from Macclesfield and farmed it out to weavers in the village. Others thought nothing of walking the 9 miles to Macclesfield to collect their own silk and then back again. By 1800 there were more than 700 weavers in the village.

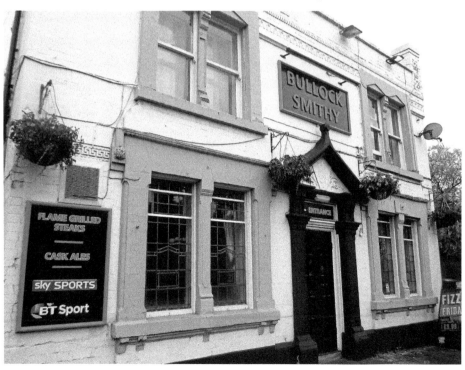

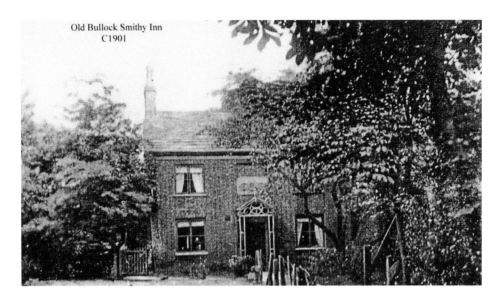

Old Bullock Smithy Inn
C1901

The Old Bullock Smithy Inn

Beyond the tram terminus and behind the trees, the original 'Bullock Smithy' Inn is visible; this is reputed have been built in 1675 and gave its name to the village before it became 'Hazel Grove' in 1836. The Bull's Head became the Bullock Smithy in 2014. By the eighteenth century, weaving was the main industry in Hazel Grove. The horse-drawn tram car was owned by the Stockport and Hazel Grove Carriage and Tramway Co., and is waiting at the terminus here to return to St Peter's Square in Stockport. It was an hourly service, costing 3d, which was payable by instalments – passengers had to pay separately at each of the three fare stages. The tram carried a post box for letters which were posted by the conductor at Stockport. The photo was taken between 1890 when the service started, taking over from horse buses, and 1905 when the route was electrified.

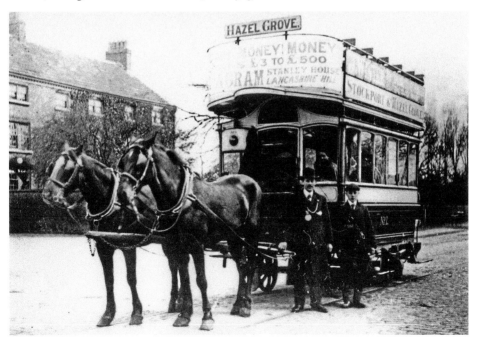

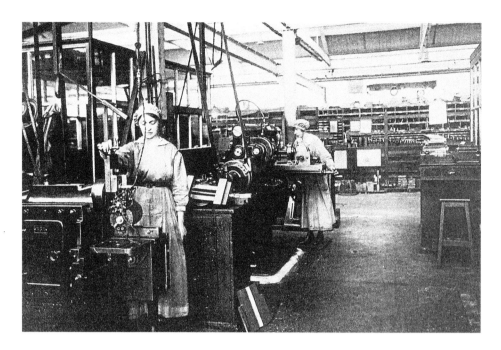

Mirrlees, Bickerton & Day

The tool room with a female operative – one of many taken on to cope with the extra work involved in producing diesel engines during the First World War. Hazel Grove, as well as producing their standard range of diesel engines, also developed a special type of oil engine for installation in the new tanks and first used in 1916 revolutionising battlefield warfare. During the war it was paramount to conserve imported fuel, so oil experiments were undertaken, using home-produced tar oil as fuel. Mirrlees created another revolutionary engineering milestone when it developed pilot injection equipment, where a small quantity of high-grade fuel oil was introduced just before the main injection of tar oil, thus enabling the engine to run on a fuel mixture that contained about 95 per cent tar oil. The lower image shows a Mirrlees truck driven by a woman during the First World War.

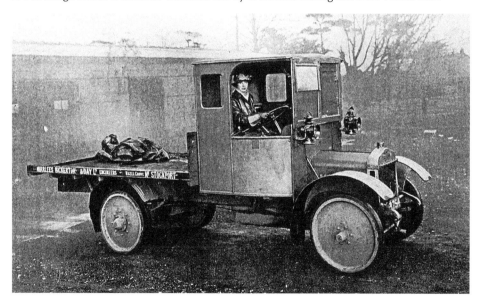

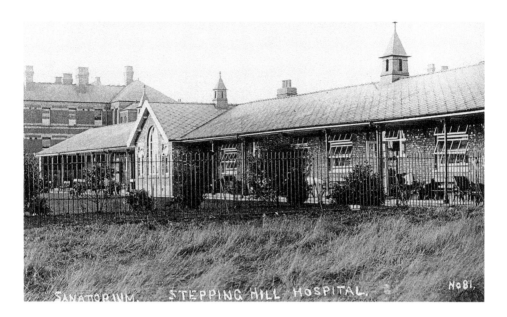

Stepping Hill Hospital

The hospital started life as a workhouse hospital, as part of the Stockport Union. The hospital opened in 1905 at a cost of £5,000 in four blocks of three wards. In 1934 it was transferred to Stockport Corporation and is now an NHS hospital. Today, urology, maternity, orthopaedic and stroke services at Stepping Hill are amongst the UK's best; it runs one of the largest orthopaedic services in the country and a specialist stroke centre serving the southern part of Greater Manchester is a centre of excellence. The UK's first prostate cancer operation using a hand-held robot was performed here in 2012.

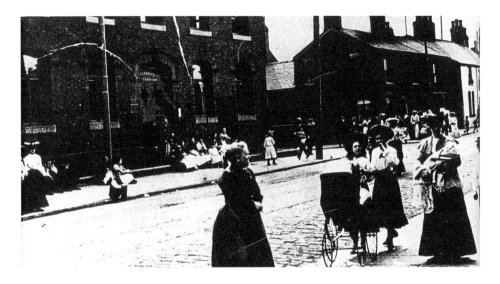

Mechanics' Institute

The Hazel Grove Mechanics' Institute can be seen on the left here, opened in a shop in 1868 by Mr Brookes, head of Norbury School. The aim of mechanics' institutes was to provide a technical education for the working man and for professionals to 'address societal needs by incorporating fundamental scientific thinking and research into engineering solutions'. They transformed science and technology education for the man in the street. The world's first opened in Edinburgh in 1821 as the School of Arts of Edinburgh. Liverpool opened in July 1823 and Manchester (later to become UMIST) in 1824. By 1850, there were over 700 Institutes in the UK and abroad, many of which developed into libraries, colleges and universities. Mechanics' institutes provided free lending libraries and also offered lectures, laboratories, and occasionally, as with Glasgow, a museum. Hazel Grove Mechanics' Institute later became the Civic Hall, as shown here.

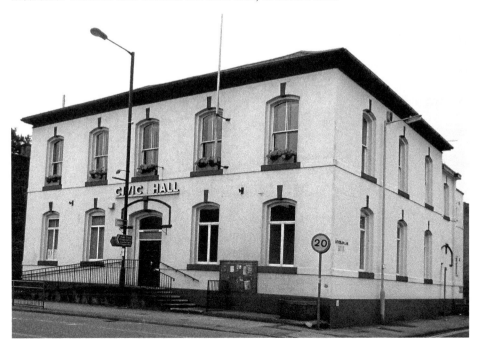

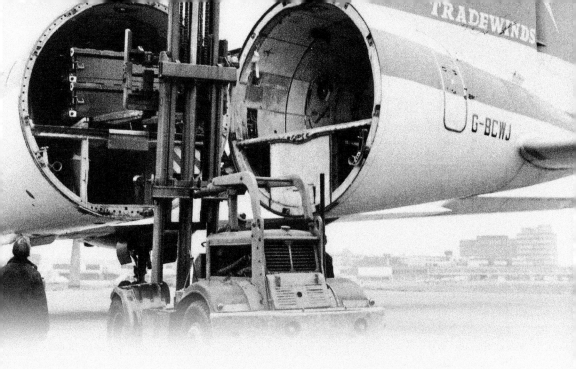

Manchester Airport

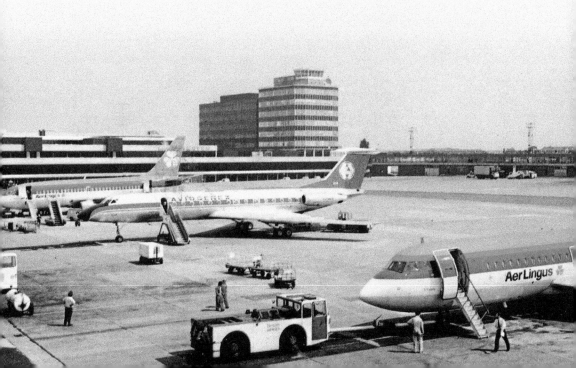

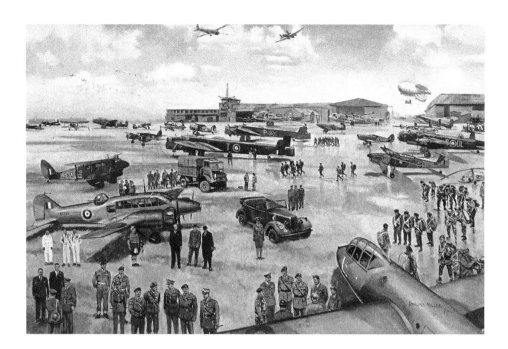

Ringway: The Pioneer Years

In the upper photograph on page 91 we have a Tradewinds freighter loading in the early 1970s. The lower photo shows an Aviogenex Boeing 727-200 at Manchester airport. Aviogenex was a Serbian charter airline based at Belgrade Nikola Tesla Airport. They went into liquidation in 2015. The Pioneer card on this page depicts a typical scene at Ringway in the summer of 1942 with the RAF's Parachute Training School, the Army Gliding Unit and a prototype Lancaster I, a York I, an Anson I and a Barracuda. The painting is by Edmund Miller GAv A, commissioned by Dan-Air and presented to the greater Manchester Museum of Science & Industry on the fiftieth anniversary of the commencement of flying at Ringway in June 1937. The lower image depicts the first Boeing 747 'Jumbo' to visit Manchester, on 17 August 1970. (© MA Archive via Ringway Publications)

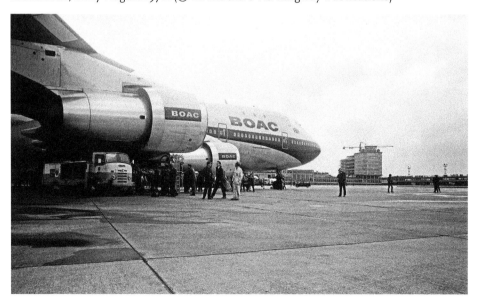

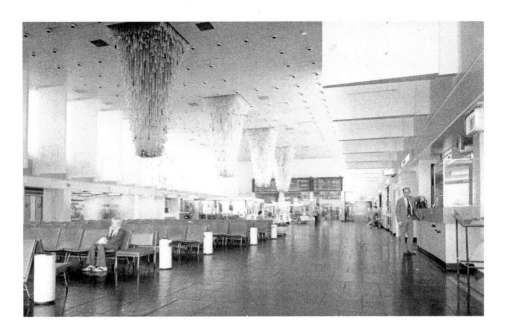

International Departures Lounge

An uncharacteristically quiet Manchester terminal building which opened at the end of 1962; the centrepiece is its four Venetian glass chandeliers in the International Departures Lounge. The other shot from the early 1970s shows a scene with something more like the traffic which typically goes through the terminal. (© MA Archive via Ringway Publications)

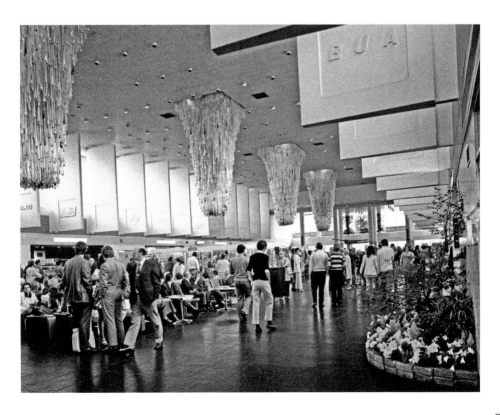

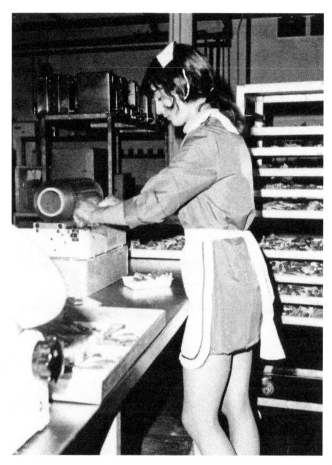

Catering in the 1960s and Flying Pigs

The uniform worn by the waitress gives this away as being in the mid- to late 1960s. In the lower photograph, we have another shot of the Tradewinds freighter loading. Founded in 1968, Tradewinds flew frequent relief flights to Nigeria during the civil war with Biafra. It also flew for the Ministry of Defence, which included the transportation of missiles to NATO arctic test ranges. Tradewinds enjoyed the exclusive contract for the transportation of Formula 1 cars around the Gran Prix circuits of the world. Tradewinds was also became a specialist carrier of bloodstock, pioneering the use of special stalls allowing horses to fly safely and without stress. Sheep, goats and pigs were also carried. The company was sold to Lonrho in 1977. This particular aircraft was written off after a heavy landing in Nairobi, Kenya, in 1978. (© MA Archive via Ringway Publications)

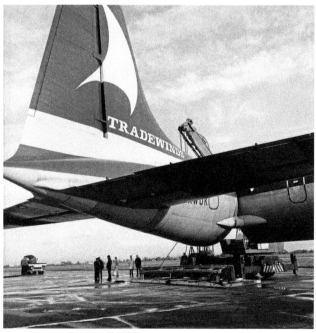

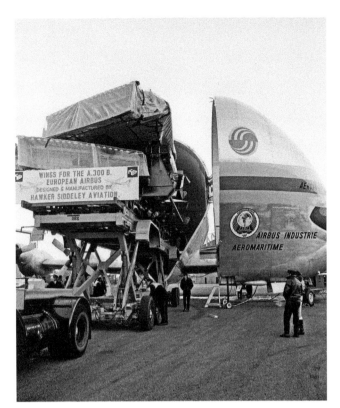

Air Traffic Control
A fascinating view of the control tower at dusk in November 1979 is depicted in the lower photograph. The upper picture is of the first flight of the transportation of wings for the Airbus to Bremen on 22 November 1971. (© MA Archive via Ringway Publications)

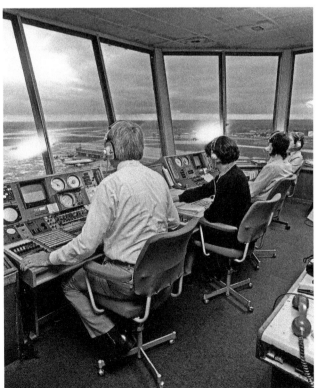

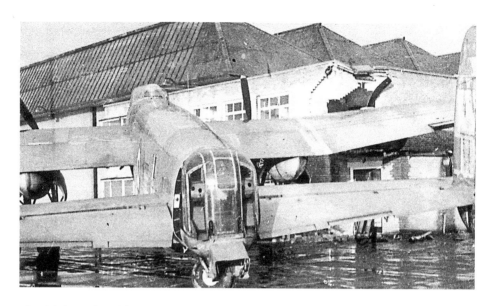

The 6th (Royal Welch) Parachute Battalion

An airborne infantry battalion of the Parachute Regiment established in 1942 from the 10th Battalion of the Royal Welch Fusiliers. They were converted to parachute duties and assigned to the 2nd Parachute Brigade, which was then serving in the 1st Airborne Division in England. All recruits to the battalion underwent a twelve-day parachute training course at No. 1 Parachute Training School, RAF Ringway. This started with parachute jumps from a converted barrage balloon and concluded with five parachute jumps from an aircraft. Anyone failing to complete a jump was sent back to his former unit. The upper picture shows an Avro Lancaster RE206 making contact in December 1948 with BEA office buildings adjoining Hangar No. 6.

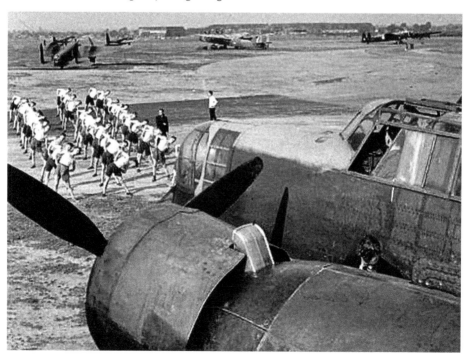